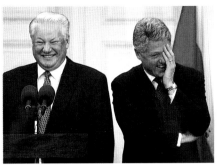

WORLD PRESS PHOTO 1996

Thames and Hudson

26 0042907 8

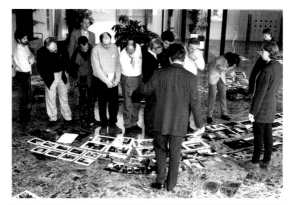

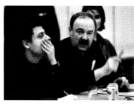
The jury at work.
During an
action-packed week in
February, the nine-member
jury fulfilled its tightly
scheduled task
on the top floor
of KLM's head office
just outside Amsterdam.
Photos: Louis Lemaire

INTRODUCTION

The World Press Photo Foundation is an independent platform for international press photography, founded in 1955. This platform manifests itself in the annual World Press Photo of the Year Contest and the corresponding yearbook and exhibition.

An independent international jury consisting of nine members judges the thousands of entries submitted by photojournalists, agencies, newspapers and magazines from all corners of the world. Since 1983 there has also been a children's jury, which separately selects the World Press Photo Children's Award.

World Press Photo publishes this yearbook in conjunction with the annual exhibition. On the one hand the book serves as a catalogue, including all prizewinning submissions of the year in question. On the other hand it is a self-contained document, reflecting the best in the press photography of a particular year. The exhibition is shown all over the world, subject to the condition that all prizewinning entries are exhibited at every venue without any form of censorship.

World Press Photo aims to increase public interest in press photography and to promote the free flow of information worldwide. It also stimulates discussion about aspects of photo-journalism among those who are professionally involved in it. This takes the form of initiating and organizing seminars and debates in different countries. The second annual World Press Photo Joop Swart Masterclass was held in 1995.

World Press Photo operates from Amsterdam, the Netherlands. The foundation is a nonprofit organization, whose activities are made financially possible by the proceeds from the annual exhibition, royalties from the yearbook and sponsorship by Canon, Eastman Kodak Company and KLM Royal Dutch Airlines. The foundation also receives a subsidy from the City of Amsterdam.

The World Press Photo governing board consists of members with a wide-ranging interest in press photography. The international dimension is enhanced by a consultative body, the International Advisory Board, which comprises experts from the world of press photography including former jury members. World Press Photo committees are active in France, the United Kingdom and the United States.

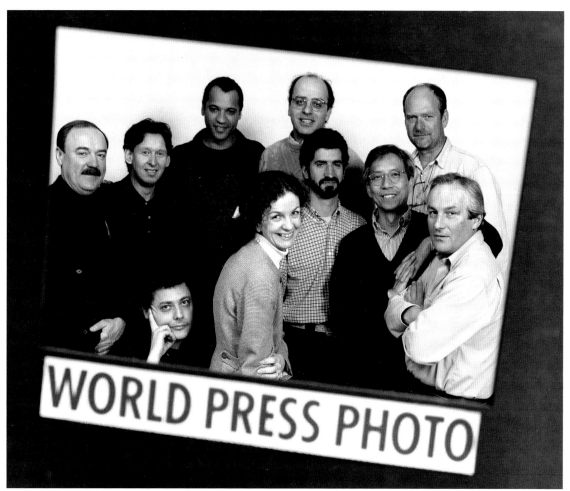

This year's jury.
From left to right:
Alexei Godunov, Russia
Adriaan Monshouwer (secretary)
Sam Mohdad, Lebanon
Mark Sealy, United Kingdom
Kathy Ryan, USA
Roberto Koch, Italy
Pablo Ortiz Monasterio, Mexico
Liu Heung Shing, Hong Kong
Dirk Buwalda, the Netherlands
Alain Mingam, France (chair)
Photo: Capital Photos

The applause which resounded at the end of the press conference announcing the results of the World Press Photo contest was in itself a reward for all the photographers who for 40 years have been adding their names to the prestigious list of World Press Photo prize-winners.

Soon statistics started coming into the first public discussions extolling the merits of a particular story or expressing amazement or incomprehension at the choice of another. The time had come to draw the first conclusions about what the work submitted by 3,068 photographers revealed or confirmed, about their talent and photographic sensibilities, which from now on would be associated with significant moments in 1995.

It was a fresh opportunity to emphasize the important and indispensable role of World Press Photo, the guiding light illuminating every year the latest contribution to the universal heritage of photography and of the press, to which this edition of the yearbook testifies. It is a book that – as it takes its place among earlier editions – holds three surprises as food for thought for the entire photographic profession.

Firstly, the amazing photograph in the Spot News category of the capsizing truck, taken by Sholihuddin of the Jawa Pos Daily. The jury could congratulate itself for seeing the principle of 'the right guy in the right place' so brilliantly illustrated, enabling them to honor both the photographer and a category frequently reduced to a narrow collection of stereotypical war shots.

The second surprise was the fact that, with 42% of all the material entered in, black and white was the 'color' dominating this contest. Across all categories, local and foreign photographers had opted for black and white, whether they portrayed daily life in Cuba or Dagestan or sport in Turkey. Photographers had chosen the more graphic possibilities of black and white to even greater effect in Rwanda, Grozny, Tuzla and Sarajevo to portray, document and denounce the violence of situations which television – that many-tentacled octopus of the banal – discards all too quickly into the abyss of history too quickly consumed.

In the era of a global village of real-time information brought to us by CNN, the prizes awarded to these pictures honor not only the winners, but all those photographers who invest time, money, and sometimes their lives to prevent the refugees and victims of barbarism of our era disappearing into a shroud of oblivion, into the black hole of our universal bad conscience.

Even if some of the jury members privately had reason to regret the absence of a particular subject – the Kobe earthquake, for instance – we never failed to respect impartially the quality of the photography, though we let ourselves be guided by our hearts and sometimes by our passions. Nor did we show any voyeurism at the gaping wounds of the world we live in, or undue complacency at great or small moments of happiness on our planet.

Finally, the third surprise: awarding the World Press Photo of the Year to the picture by Lucian Perkins of The Washington Post. I am convinced that even if tomorrow you will no longer be moved by the sheer beauty of this picture, the eyes of the Chechen child escaping from the war will touch your subconscious as his raised hands command time to stand still to better catch your eye.

There is no reason to conceal the fact that the debate surrounding the final vote was the most animated and controversial of the entire week. But in the light of the quality of the work already selected for awards earlier, the jury saw fit to give the most prestigious award to this deliberately non-conformist image of the theater of war in Chechnya.

What better way to shake up conventions and stereotypes? Right or wrong, everyone is entitled to an opinion. But no one can challenge the historical importance of World Press Photo as a promotional tool and as a means of revitalizing the press photograph and of reflection on the way it is used.

On behalf of all members of the jury I thank the remarkably efficient organization as well as all participating photographers – whether they won a prize or not – without whose work we would not have experienced a week of such rich rewards for the eye, the heart and the intellect. As one symbol of this contest I would like to retain the moving portrait of Kim Phuc, 'the napalm girl', taken by Joe McNally for Life Magazine 23 years after Nick Ut's terrifying photograph, elected World Press Photo of the Year 1972.

There can be no greater reward for a war photographer than the suppression of violence, paradoxically the very subject of his work as an indispensable and privileged witness with a camera. Just as World Press Photo never fails to present a new list of winners to the world every year, so the photographers of the world must never lose faith in their difficult and noble profession.

ALAIN MINGAM
Chairman of the 1996 Jury

Paris, February 1996

WORLD PRESS PHOTO OF THE YEAR

LUCIAN PERKINS
The Washington
Post,
USA

**WORLD PRESS
PHOTO
OF THE YEAR**

**FIRST PRIZE
GENERAL NEWS
SINGLES**

9601

9601
The civil war which erupted when President Yeltsin sent troops to the rebellious province of Chechnya in December 1994 was still dragging on months later. When the Chechen fighters fled Grozny, the capital, where the war had claimed a horrendous toll in both human and material terms, Russian troops pursued them into the countryside to the south and east. In May, the photographer visited some villages and hospitals close to the new war zone. On the way back to Grozny he found himself behind this bus and was struck by the face of a boy pressed against the rear window. It was a face which symbolized all that he had seen.

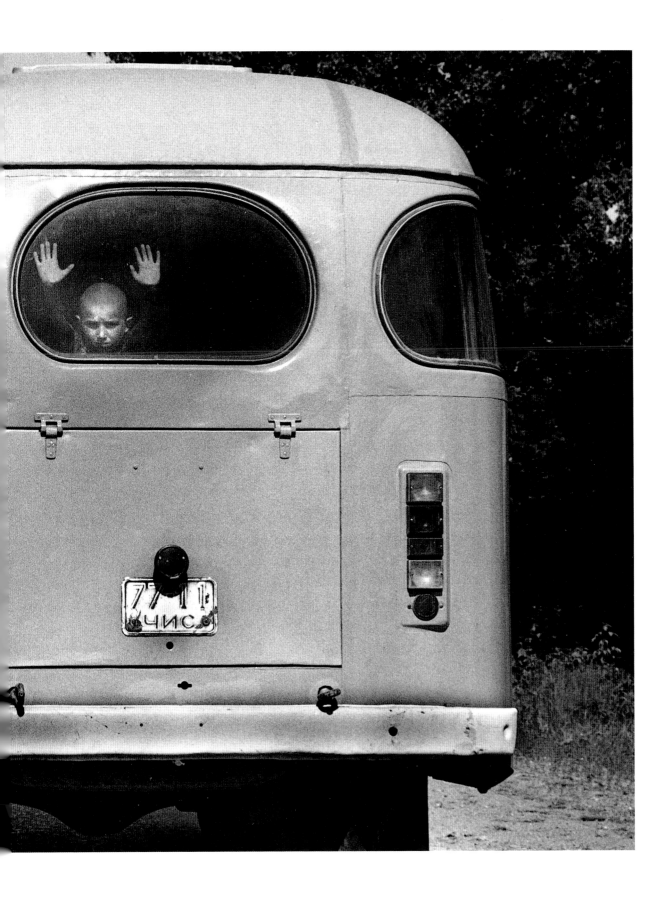

LUCIAN PERKINS
was born in
Fort Worth, Texas,
in 1952. Before
taking up photogra-
phy, he graduated in
biology at the
University of Texas.
Since 1979 he has
been a staff photo-
grapher at The
Washington Post.
In 1993 he was
based in Moscow
for six months.
Perkins was the
1994 Newspaper
Photographer of the
Year of the
US National Press
Photographers
Association, and in
1995 he and repor-
ter Leon Dash
received a Pulitzer
Prize for their stories
on poverty in
Washington DC.
His work has been
published in a wide
variety of magazines
and newspapers.

Photo: Bill O'Leary

**LUCIAN PERKINS, AUTHOR OF
THE WORLD PRESS PHOTO OF THE YEAR 1995,
TALKS ABOUT HIS PHOTOGRAPHY**

At what point did you choose a career in photography?
I studied biology, but I knew all along that I didn't want to do that as a career. Then I took a photography course. It went so well that I applied for a job with The Daily Texan, one of the best student-run newspapers in the country. The day I got that job, it suddenly struck me that this was what I wanted to do with my life.

How would you describe your photography?
I see myself as documenting society in all its aspects, the tragedies as well as the hope and the humor. I consider it a challenge to cover all segments of society, also – or perhaps especially – those that may seem mundane or boring. A good example is a story I once did for the Washington Post Sunday Magazine on tourists visiting Washington DC. I saw them as a culture in themselves, with their own visual language in the way they dressed, walked and behaved. When I suggested it, the editors gave me blank stares, but when they saw the pictures they loved them.

Do you often suggest ideas for your assignments?
Yes, I believe that is one of my strengths. The key to having good ideas is to keep your mind open to what is around you, which is not as easy as it sounds. Doing regular newspaper assignments keeps you in the mainstream of the real world. It gives you the opportunity to look around, come up with new ideas and perhaps turn an unexciting subject into something better.

Do you have a preference for color or black and white?
I prefer black and white. It concentrates the attention on the image. Color can detract from the communicative power of a great photograph, but at the same time it can save a mediocre picture by making it more interesting. There are times when color can be very helpful. The tourists in Washington I mentioned earlier often wore loud, outrageous color combinations, which were an integral part of who they were. That made it important for me to shoot them in color.

Do you find it difficult to combine local and international assignments?
I like the variety. Here in the US, I am particularly interested in photographing 'Americana', the daily life of Americans. But I have also covered a lot of international news: the Palestinian uprising, the Gulf War, Bosnia. I prefer not to have to travel to remote international hot spots for what you could call 'quick hits'. I'd rather concentrate on places I know and like, where I can develop long-term relationships with people and shoot more in-depth material. Russia is the best example. I have been going there since 1988, and I have a lot of respect and admiration for Russian photographers.

They are coming up with wonderful images and have a real sense of mission. They do their job for the love of photography, although they often lack funds and proper equipment. That so impressed me that I got involved in exchange exhibitions and a photojournalism conference in Moscow. It's very gratifying to me to see that as a result of the conference some Russian photographers are now getting international recognition.
Russia also fascinates me as a country. In many bizarre ways, it reminds me of America. They are both vast countries, isolated in the same way. The political situation also brought out similarities – you can compare Zhirinovsky to Buchanan, for example. And there are other parallels, as well as differences. Russia's culture, history and traditions date back to the days before the US even existed. I visited the Soviet Union before the end of communism, so I can appreciate how dramatic and difficult the current changes are for the Russian people. It's a great story, one I want to continue following over the years.

In the light of your preference for in-depth coverage, does newspaper photography really suit you?
It has both strengths and weaknesses. The variety of assignments is an important strength. A weakness is the danger that it can stifle you. If you're not careful, you can lose sight of your own style. Newspapers tend to want very tight shots. In order to avoid getting trapped in that style, I constantly re-evaluate for myself what I am doing. Fortunately, a lot of barriers have been broken down in the last few years, particularly at The Washington Post. We have a very diverse team shooting exciting stuff, and the newspaper is going for it. It's opening itself up to different styles, using images that would have been rejected before.

Do you see yourself as a purely documentary photographer?
I don't distinguish between documentary and, for example, art photography. In my view, they are the two areas in photography where the best work is made. I believe they have been merging in recent years, which is a positive development. A personal style can convey the artistic aspect in someone's work, even if it's not *called* art.
The advantage photography has over any other art form is its ability to freeze a moment in time, allowing the viewer to see things which would otherwise remain hidden. Documentary photography presents history, culture and the world around us in a deeper way than any other medium. That can be very revealing, and I believe it is the characteristic that will ensure the future of photojournalism.

How do you define your own role as a photographer?
I hope that, by looking at my photographs, people will develop a better understanding of the world around them and more empathy with the people in it.

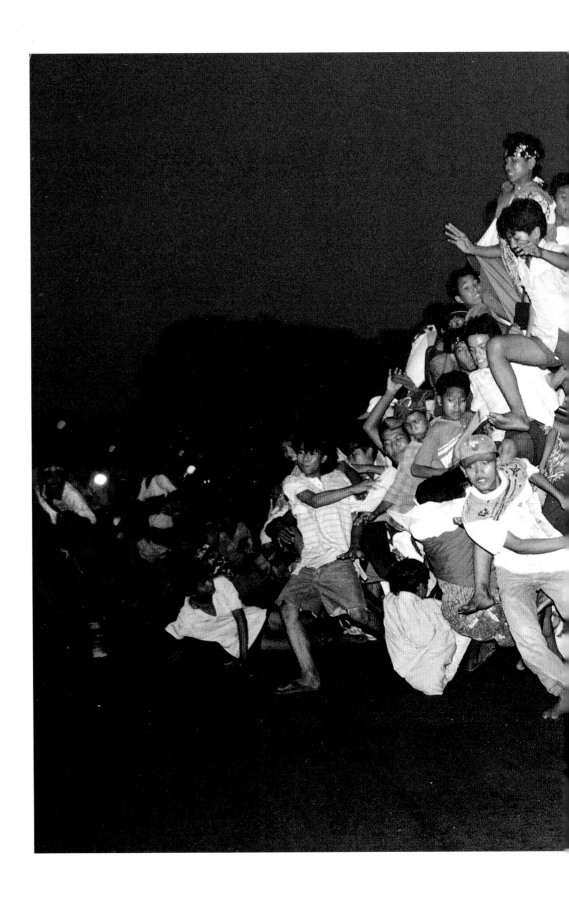

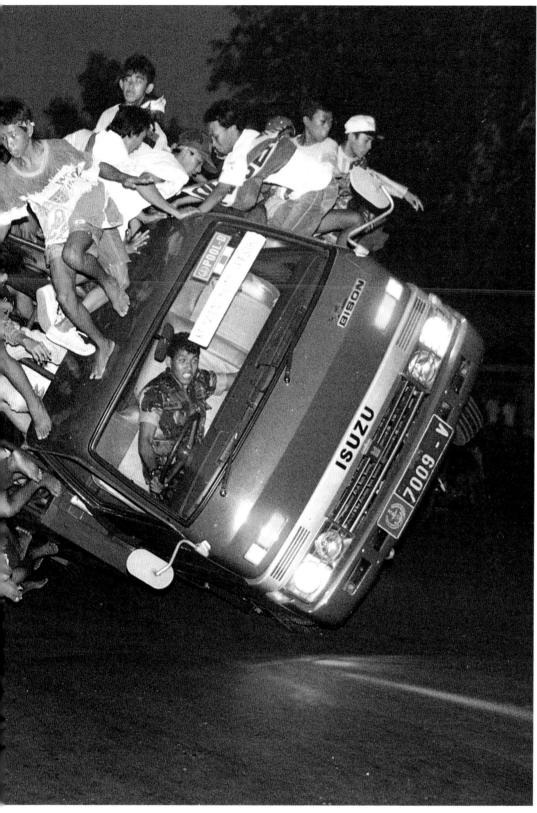

SHOLIHUDDIN
Jawa Pos Daily,
Indonesia

**FIRST PRIZE
SINGLES**

9602

9602
In May, a military truck carrying over 100 youths keeled over under its heavy load in Surabaya, East Java. The passengers were supporters of local football club Persebaya, who were enjoying a free ride home and waving flags to celebrate their team's victory.

The truck – one of 24 made available by a military commander – capsized after only one kilometer. Most of the passengers escaped unharmed, but 12 of them had to be hospitalized with minor injuries.

**PATRICK
CHAUVEL**
France,
Sygma
for Newsweek
Magazine,
USA

**FIRST PRIZE
STORIES**

9603

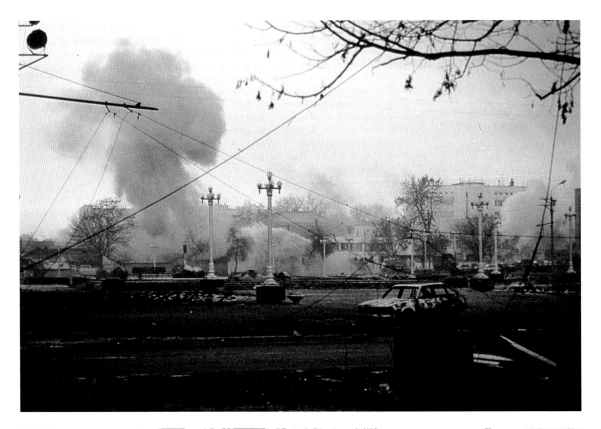

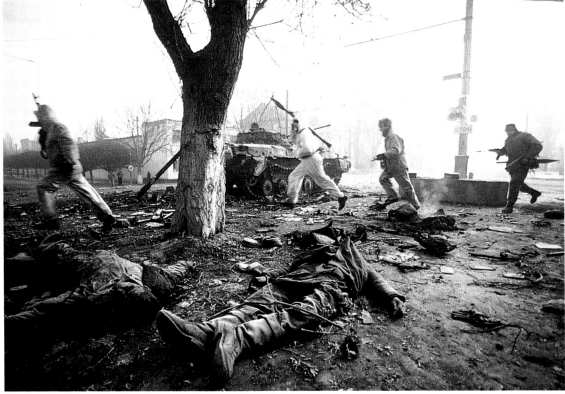

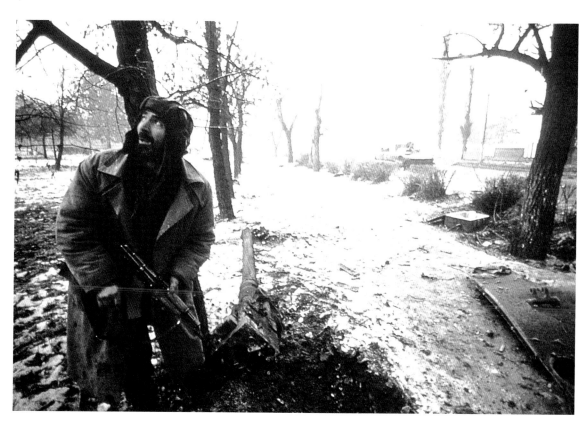

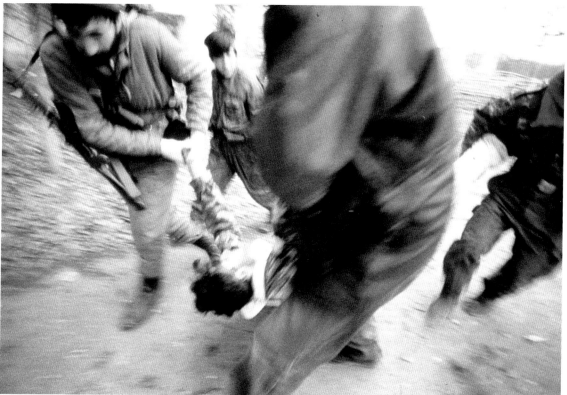

9603

January saw some of the fiercest fighting since the start of the struggle for Chechen independence. After negotiations to persuade Chechnya to recognize Moscow's authority had failed, President Yeltsin sent in the army in December 1994. But the troops were badly motivated and poorly equipped, and the battle for the capital of Grozny raged for weeks.

Facing page, top: Smoke rises in Grozny where shells have recently landed. The other pictures show Chechen fighters running past slain Russian soldiers to new positions, cowering under enemy fire and dragging the body of a wounded rebel to safety (story continues).

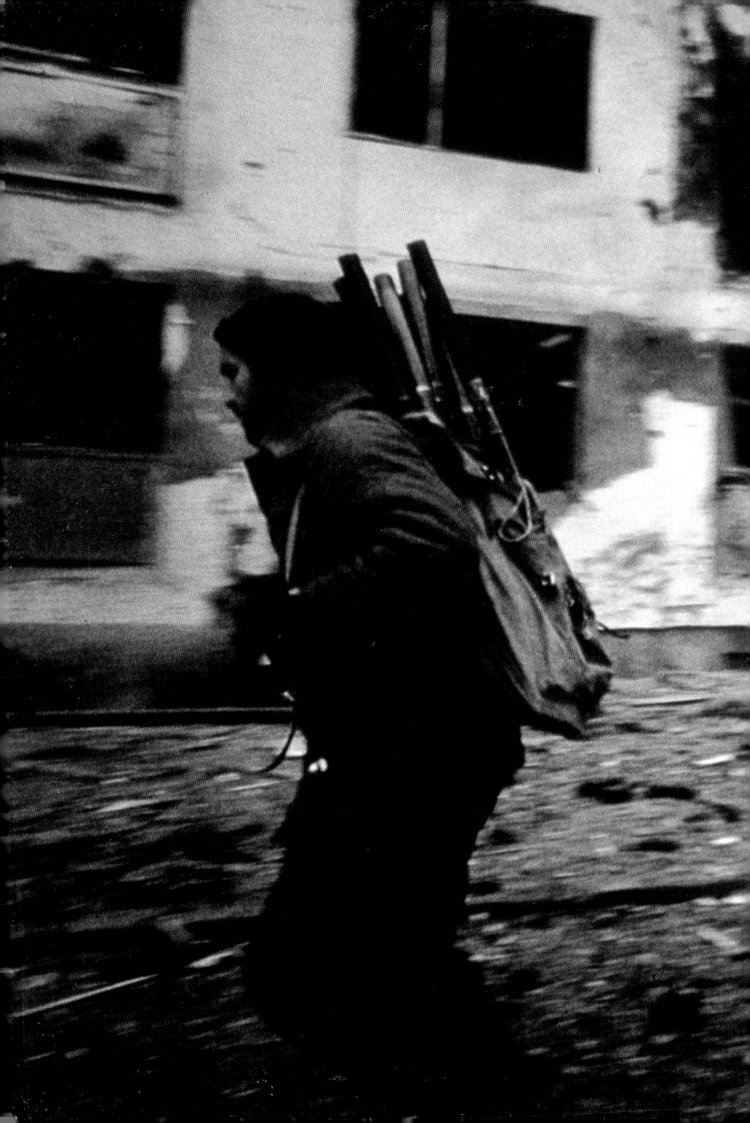

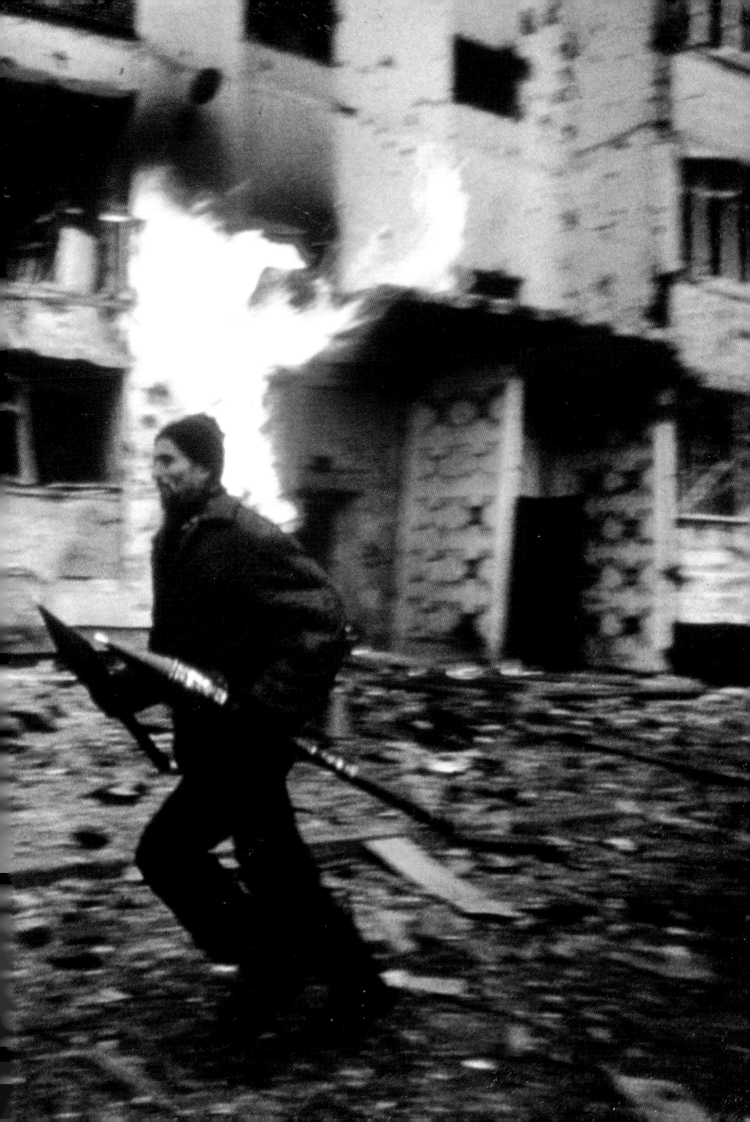

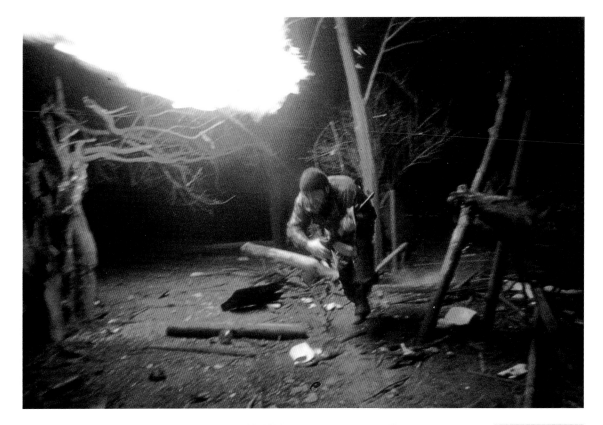

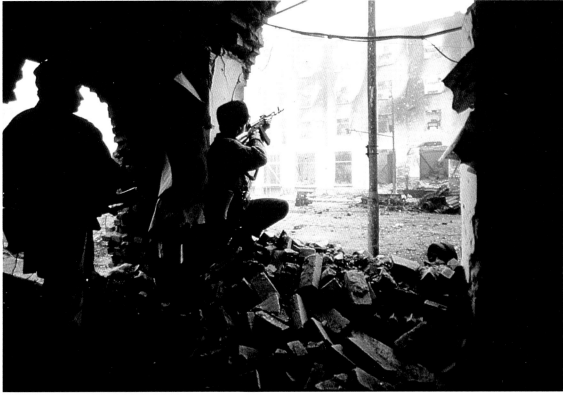

9603 (continued)
There were claims that in the face of tenacious opposition the Russian air force was bombing its own troops as well as civilian targets such as hospitals. Thousands lost their lives and many more became homeless. With three-quarters of the population disapproving of his policies, Yeltsin's popularity reached an all-time low.

Previous pages: Chechen fighters dash from a fire to take up new positions. This page: Rebels duck under fire and take aim from a ruined building. Facing page: There were casualties on all sides: a Russian soldier and a civilian lie dead in the streets of Grozny.

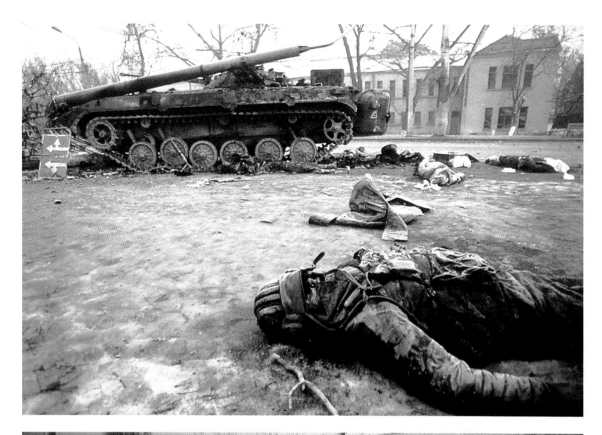

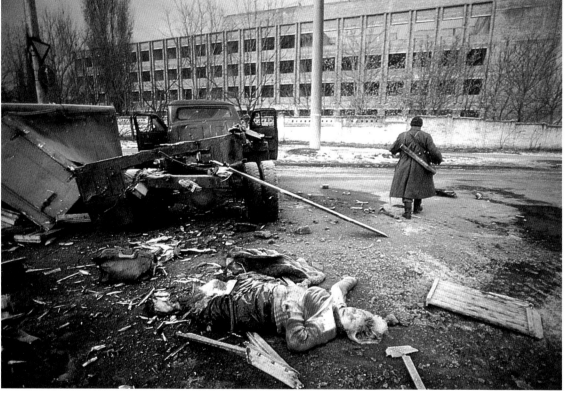

CAROL GUZY
The Washington
Post,
USA

**SECOND PRIZE
SINGLES**

9604

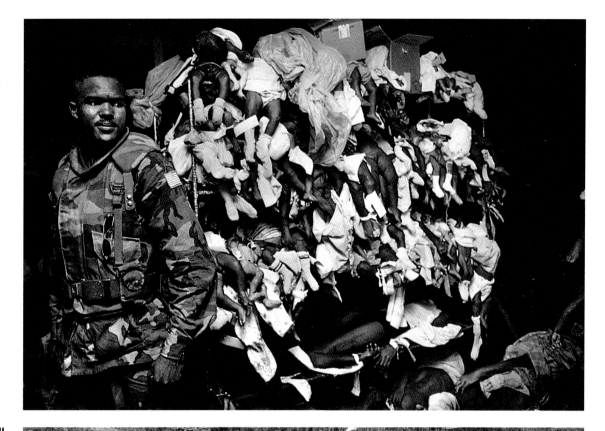

ANTHONY SUAU
The New York Times
Magazine,
USA

**HONORABLE
MENTION
SINGLES**

9605

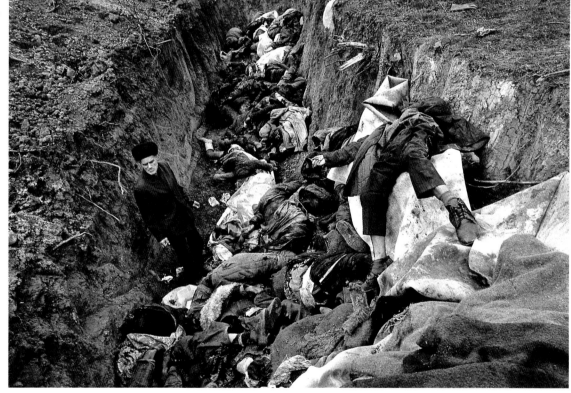

9604
The year after the US military intervention of
Haiti found American soldiers back in the
country as part of a UN mission to give peace
and democracy a better chance. Here a milita-
ry policeman stands near a pile of unclaimed
bodies at the city morgue. He had come to
identify a suspected gang member.

9605
In Grozny, Chechnya, a man searches a mass
grave for something he dreads to find: his two
missing sons. He found one of them. In the
aftermath of January's terrible fighting, sifting
through these outdoor morgues became part
of the daily routine for many who had lost
track of relatives and friends.

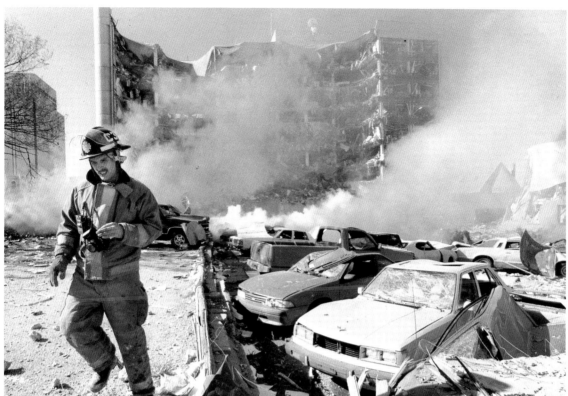

JIM ARGO
Daily Oklahoman/
Saba Press Photos,
USA

**THIRD PRIZE
SINGLES**

9606

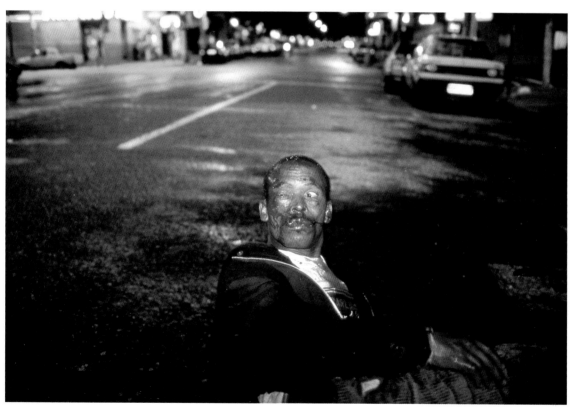

**CHRIS
STEELE-PERKINS**
Magnum Photos,
UK for Der Spiegel
Magazine,
Germany

**HONORABLE
MENTION
SINGLES**

9607

9606
April 19, 1995, was a black day in the history
of the USA. At 9:02 am a bomb hidden in a
truck totally destroyed the Alfred P. Murrah
Federal Building in Oklahoma City. The 168
people killed included 19 small children.
Right-wing extremists were charged with the
blast. Here a fireman runs through the debris
looking for victims.

9607
In Hillbrow, a multi-racial district of
Johannesburg, a man lies injured in the
street. He was beaten up while trying to steal
a taxi. The crime rate in post-apartheid South
Africa is alarming, with owners of luxury cars
most at risk. Sophisticated crime operations
organize large-scale car theft and resale –
sometimes abroad.

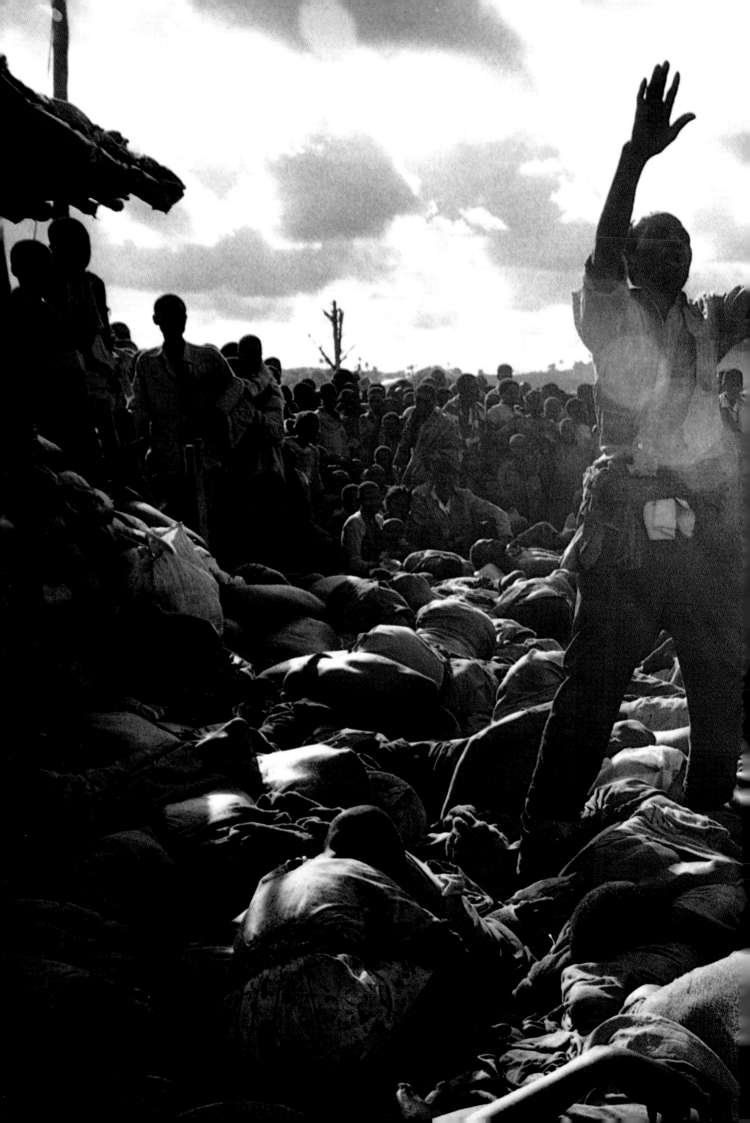

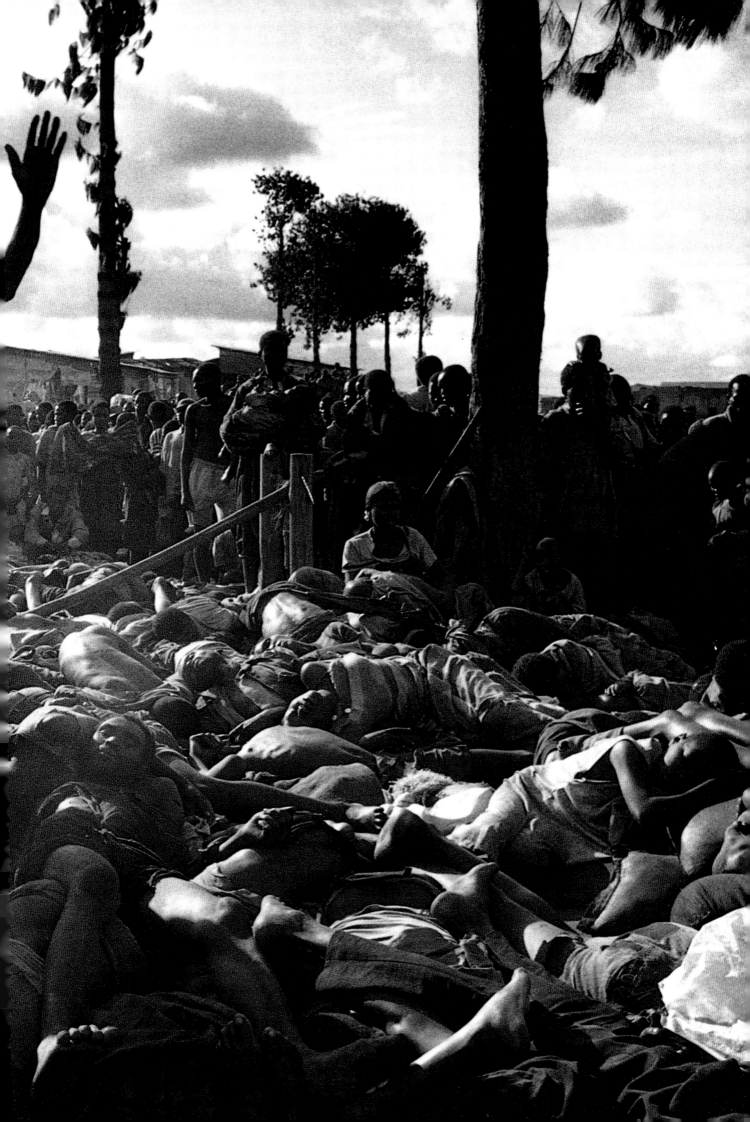

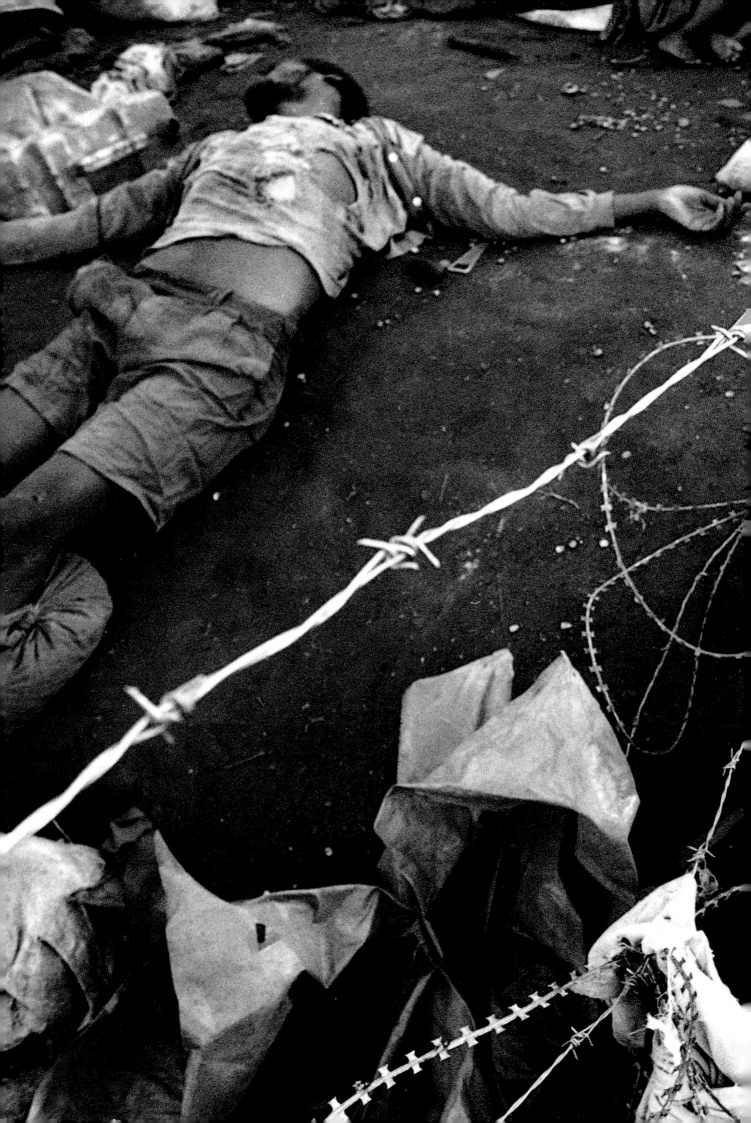

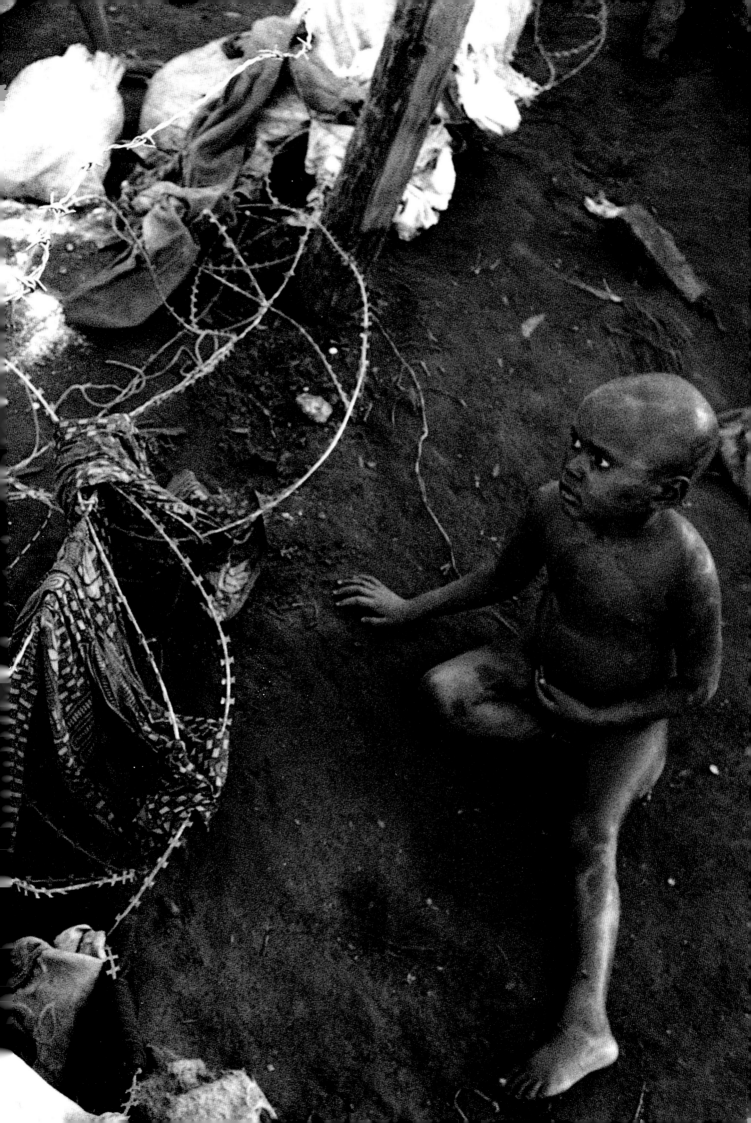

PAUL LOWE
Magnum Photos,
UK for
Newsweek
Magazine,
USA

**SECOND PRIZE
STORIES**

9608

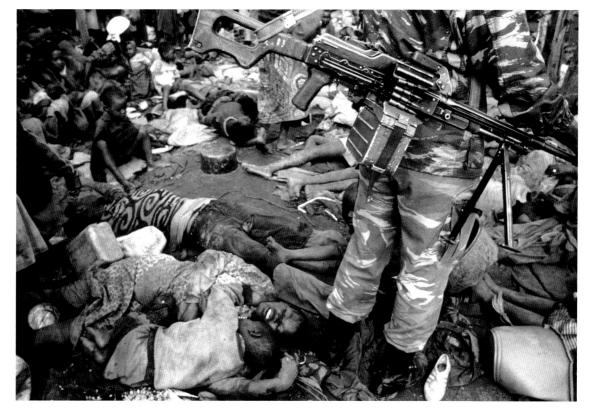

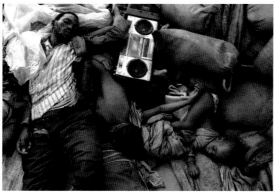 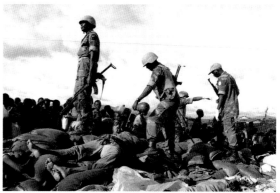

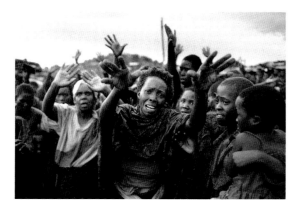

9608 (story starts on p. 20)
Violence erupted anew in Rwanda when Tutsi
soldiers of the Rwandan army massacred
Hutus at Kibeho refugee camp. In early April
plans to close the camp went badly wrong,
and in the confusion the soldiers opened fire.
The number of casualties, put at 2,000 by the
media, was contested by the government who
insisted no more than 300 were killed.

The previous pages show the aftermath of the
tragedy. This page from top: A Rwandan sol-
dier surveys the carnage. A family lie dead
among their possessions. UN troops pour
water onto weakened survivors, and Hutus
plead for protection. Facing page: Orphaned
children are watched over by a soldier.
Bodies are tipped into a mass grave.

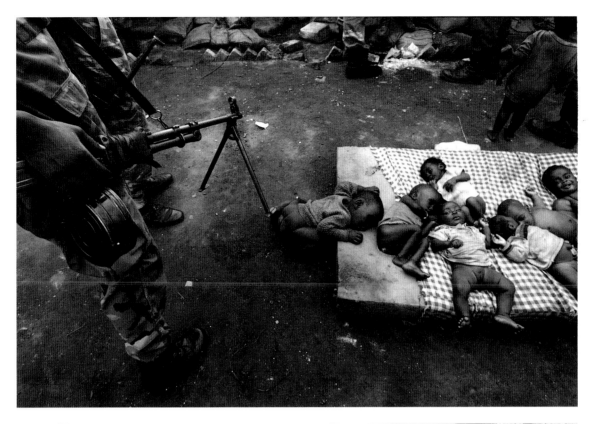

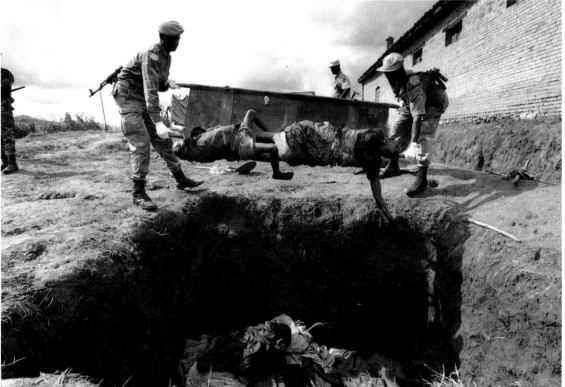

JON JONES
UK, Sygma,
France

**THIRD PRIZE
STORIES**

9609

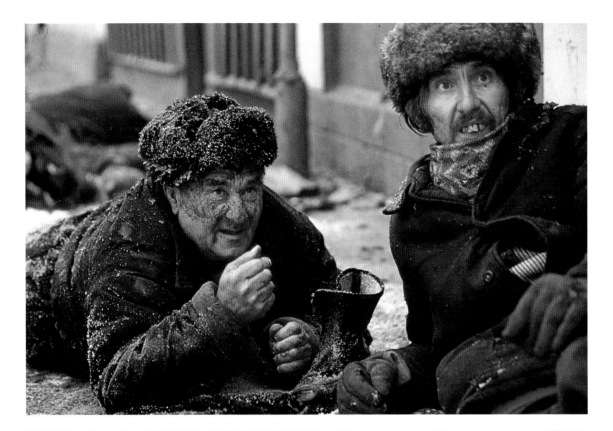

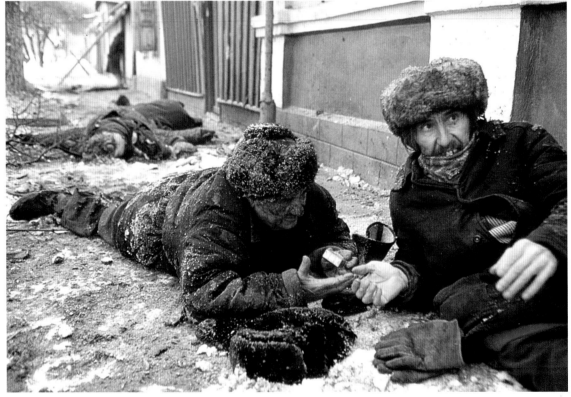

26

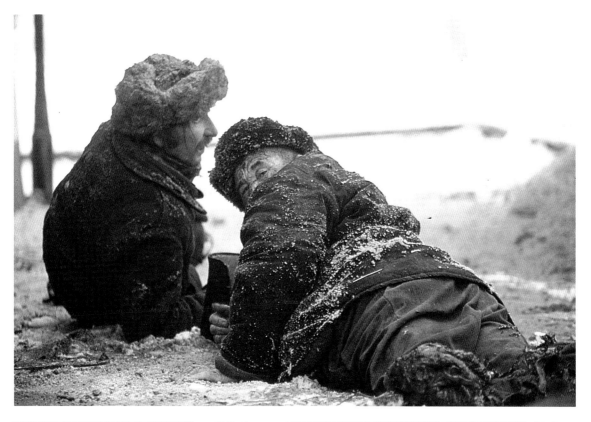

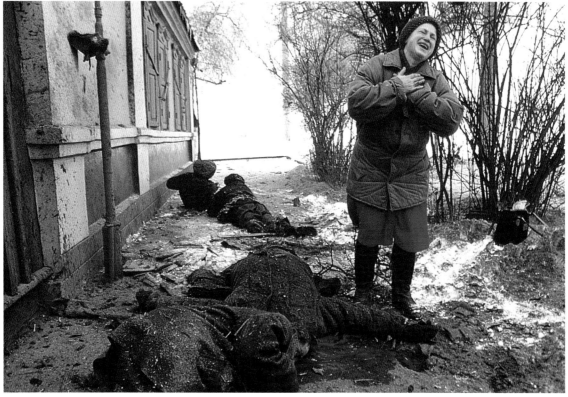

9609
Many of the victims of January's heavy fighting in Grozny were Russian civilians, who had often lived in the Chechen capital for decades. These men were pictured minutes after a Russian artillery attack, which hit the area while they were waiting for bread to be distributed.

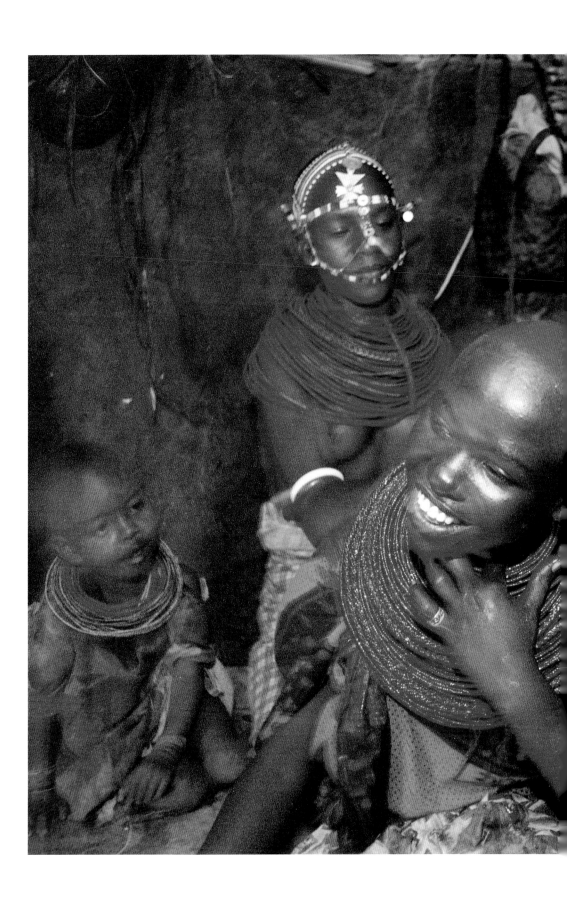

**STEPHANIE
WELSH**
Newhouse
News Service,
USA

**SECOND PRIZE
STORIES**

9610

9610
In Africa, female circumcision is widespread. In some areas the practice is virtually universal, in others (such as Egypt and Kenya) it affects about half of all girls. In Senegal and Tanzania 10 to 15 percent of girls are circumcised. Of the four different types of operation, total infibulation – where only a tiny vaginal opening remains – is the most severe. Despite the pain and anguish caused by this genital mutilation few women are opposed to it, because it lends them a higher status in their communities and is a prerequisite for marriage and childbearing. It is estimated that two million girls annually have their genitals wholly or partly removed
(story continues).

9610 (continued)
This is the story of Seita Lengila (16), who lives in Kenya's Rift Valley. The night before the ritual, her head was shaven and she was painted with ceremonial red ocher by girls from surrounding villages (overleaf). At top, she is held down by other women during the operation, which is carried out with a double-edged razor blade. Goat's fat is applied to help stem the flow of blood. Facing page from top: When it's all over, Seita sits crying in her house as some of her father's six wives and the circumciser sing and dance outside. Later, she staggers out to the bush to examine herself.

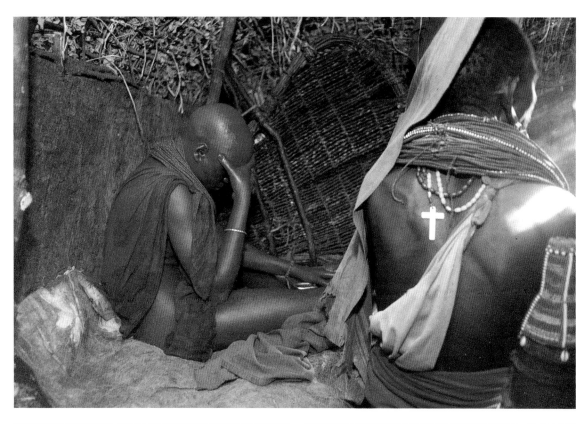

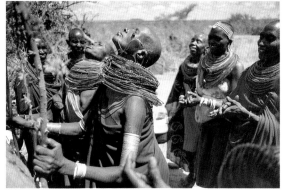

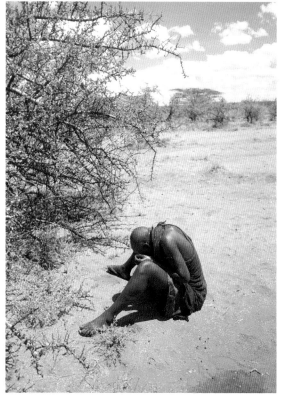

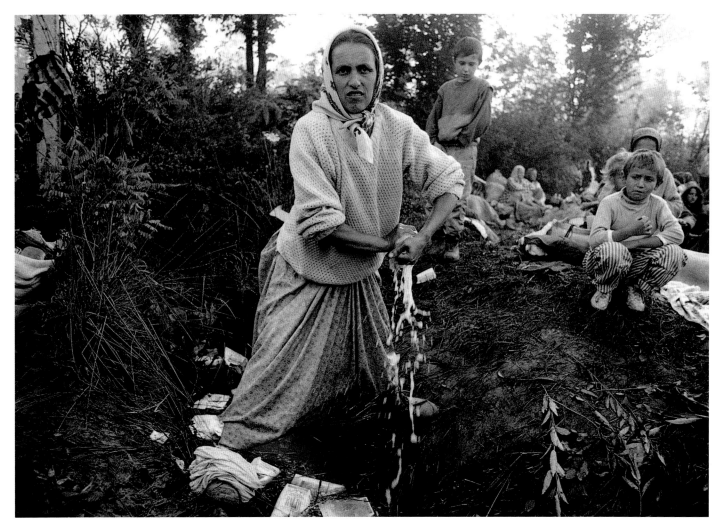

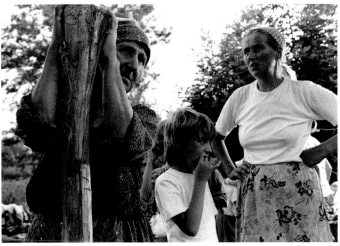
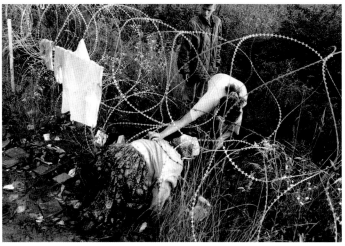

NADIA
BENCHALLAL
Contact Press
Images,
France

THIRD PRIZE
STORIES

9611

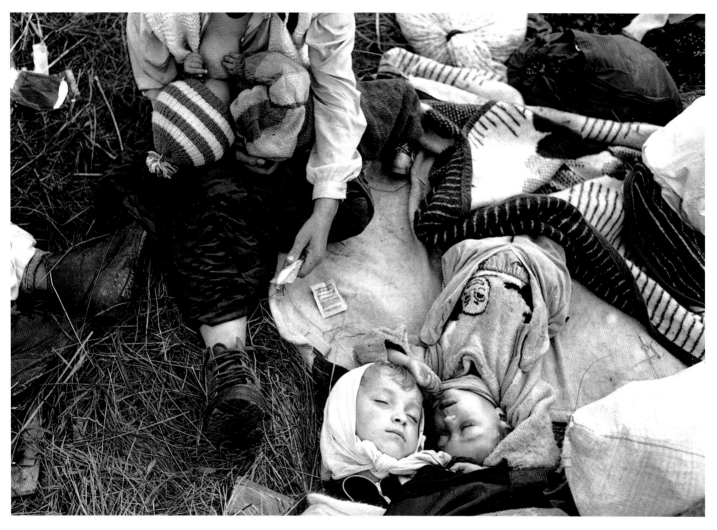

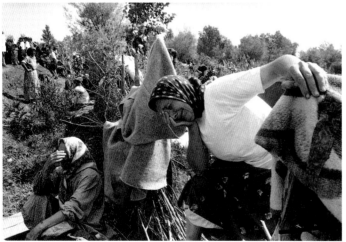

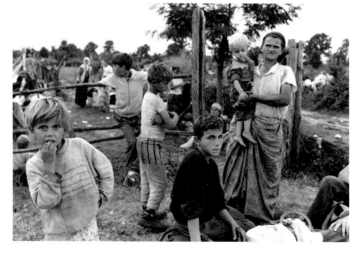

9611

After the fall of 'safe areas' Srebrenica and Zepa in former Yugoslavia to the Bosnian Serbs, convoys packed with Muslim women, children and old men were despatched north to Tuzla in an attempt to ethnically cleanse the area. At the height of the crisis, a refugee camp improvised on the airport tarmac had some 223,000 inhabitants.

This story shows the plight of the women. By and large countryfolk, they were badly equipped to deal with the new situation. Despite the gnawing uncertainty about the fate of their men, they did their best to establish a semblance of normality. But the alien social realities of life in the camp were a constant reminder of what they had left behind.

BARBARA KINNEY
The White House,
USA

**FIRST PRIZE
SINGLES**

9612

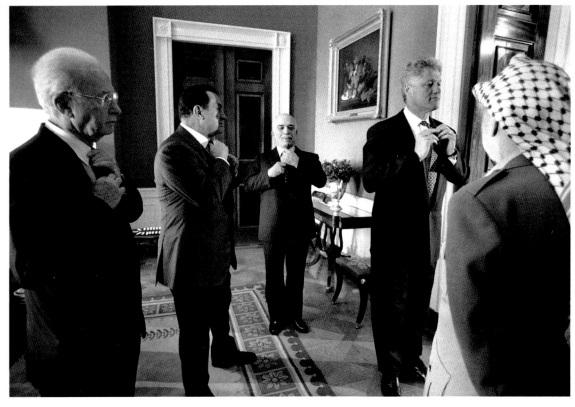

**JAMES
NACHTWEY**
Magnum Photos
for Time Magazine,
USA

**SECOND PRIZE
SINGLES**

9613

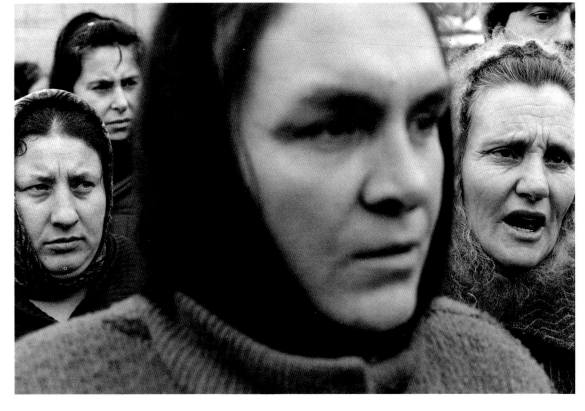

9612
On September 28, PLO leader Yasser Arafat,
Israeli Prime Minister Yitzhak Rabin, Egypt's
President Mubarak and King Hussein of
Jordan gathered at the White House to sign
an accord to expand Palestinian self-rule on
the West Bank. Taking their cue from
President Clinton, they all adjusted their ties
before the ceremony.

9613
During January's bitter fighting for posses-
sion of Grozny between Russian troops and
Chechen rebels, a group of mothers of
Russian soldiers took the initiative to travel
down to the Caucasus to bring back their
sons. They were met by this group of angry
Chechen women, whose sons were in the
opposite camp.

JOE MCNALLY
Life Magazine,
USA

**THIRD PRIZE
SINGLES**

9614

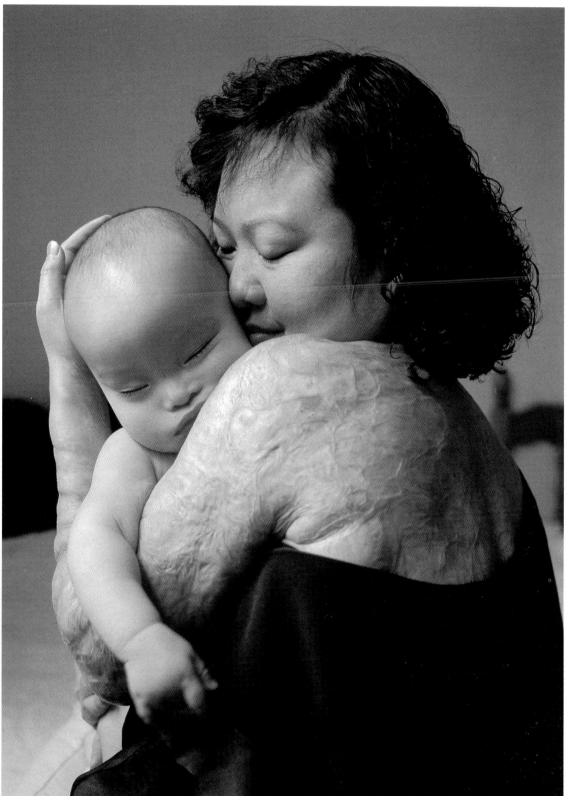

9614
Twenty-three years on. When she was nine,
Kim Phuc's village in Vietnam was hit by US
napalm. The photograph Nick Ut took of her
as she ran burning down the road – the 1972
World Press Photo of the Year – is widely
believed to have hastened the end of the war.
Kim Phuc, who now lives in Toronto, is
pictured here with her baby son.

DEREK HUDSON
UK, Life Magazine,
USA

**FIRST PRIZE
STORIES**

9615

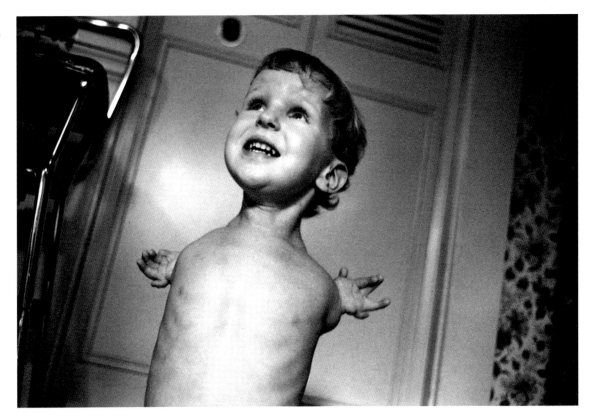

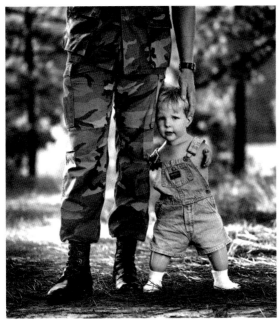

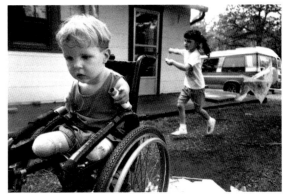

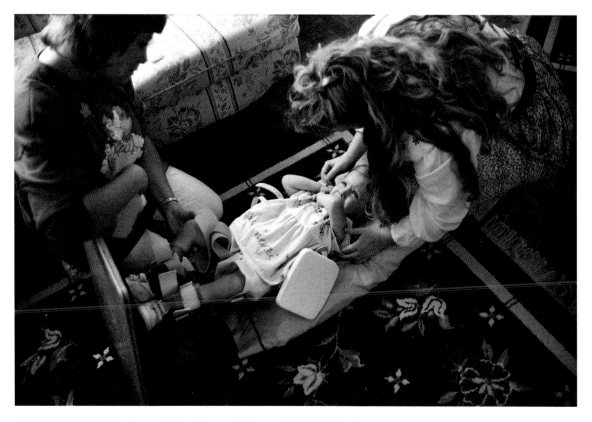

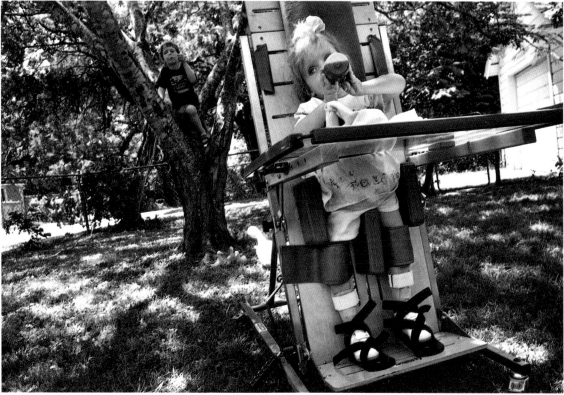

9615

Some children of US Gulf War veterans were born with multiple birth defects. Suggested causes of this 'Gulf War syndrome' range from chemicals and radiation to an unknown germ. The Pentagon officially denied the existence of a 'mystery illness'. Two of the children affected are Jayce Hanson and Lea Arnold, both three years old. Jayce (facing page) has had his legs amputated to make it possible to fit prostheses. At top, he appeals to his mother to help him pick up a toy. Bottom right: Jayce tries to fly a kite with his sister Amy. This page shows Lea, who was born with spina bifida among other defects. She has to spend long periods in a contraption holding her upright to strengthen her bones.

BILL BELKNAP
Boston Herald,
USA

**FIRST PRIZE
SINGLES**

9616

9616
During a midsummer baseball game at
Boston's Fenway Park, Red Sox shortstop
John Valentin avoids being doubled off first
base, but can't avoid catching the ball in the
face. It happened in the third inning of a
match against the Detroit Tigers. The home
team was beaten 7-6.

FRANCESCO CITO
Italy

**FIRST PRIZE
STORIES**

9617

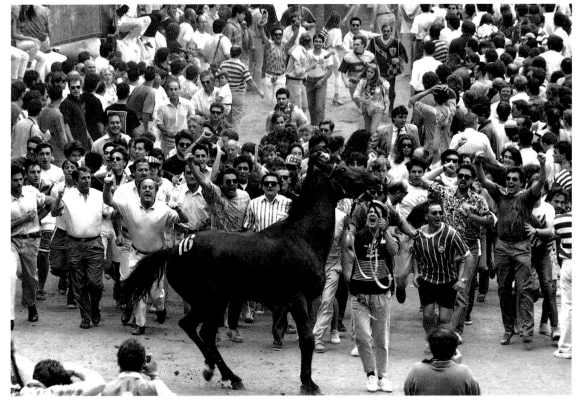

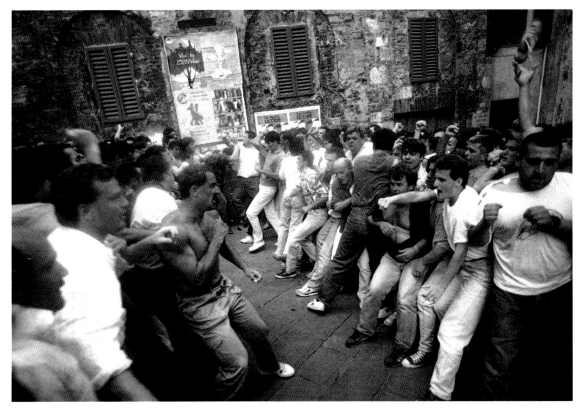

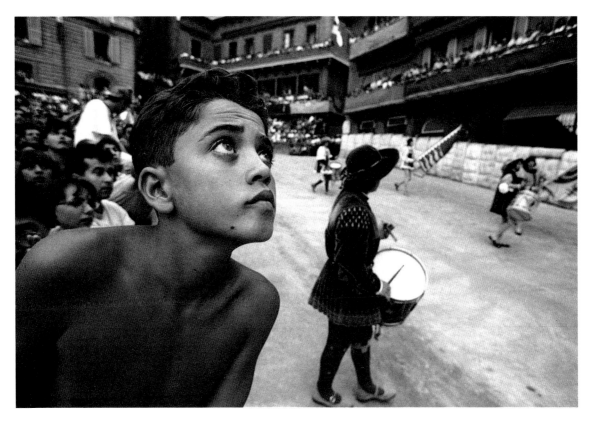

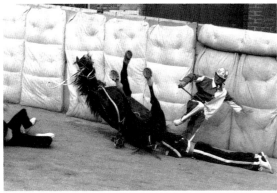

9617
To outsiders the Palio of Siena, Italy, is just a colorful 90-second horse race around a town square. To the Sienese it is the very essence of their complex social structure. Sport, religion, bribery, rivalry and adulation are just some aspects of this unique event, held twice a year in honor of the Virgin Mary. Ridden bareback, the ten horses representing different quarters of the town can win even if they have jettisoned their jockey. Glory awaits the victorious quarter, while defeat is considered a disgrace. Facing page: Euphoria and hostility on the verge of eruption. This page: Costumed drummers are part of the ritual. Spectacular fall in the treacherous San Martino bend, and the winning jockey is carried into church to give thanks.

KEITH BERNSTEIN
Independent
Photographers
Group,
UK

**SECOND PRIZE
SINGLES**

9618

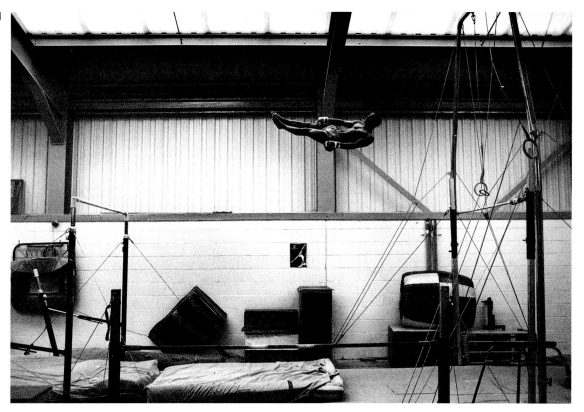

STEPHEN DUPONT
Australia,
Independent
Photographers
Group,
UK

9619

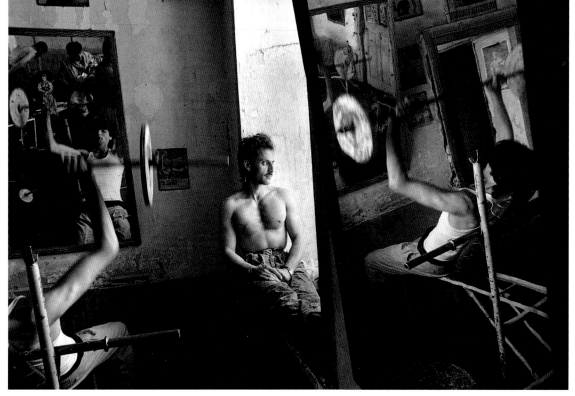

9618
Around the world, training schedules for the
1996 Olympic Games in Atlanta are rigorous-
ly followed many months before the flame is
lit. Here British gymnast Kanukai Jackson is
shown in full swing as he dismounts from the
parallel bars.

9619
Working out at a makeshift gym in Kabul. The
self-contained world of the fitness club offers
some relief from the harsh realities outside:
80 percent of the Afghan capital lies in ruin.

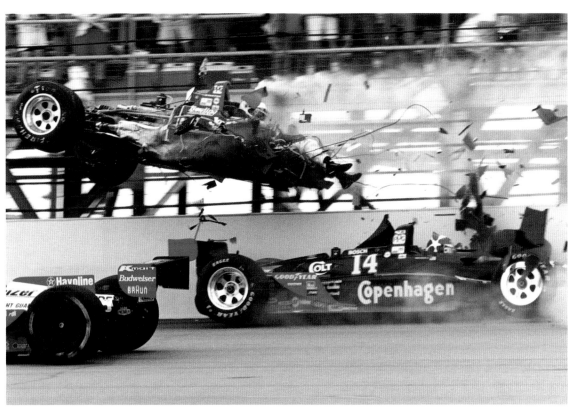

JAMES STEWART
Associated Press,
USA

**THIRD PRIZE
SINGLES**

9620

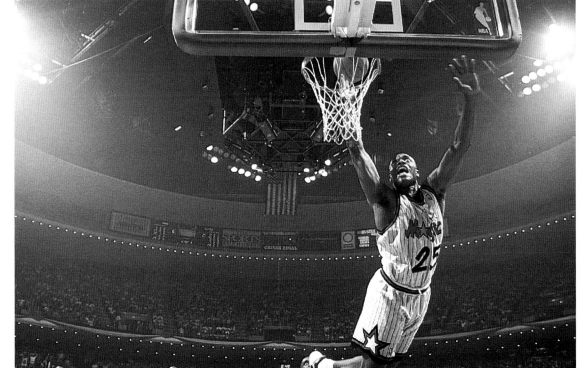

GARY BOGDON
The Orlando
Sentinel,
USA

9621

9620
Racing driver Stan Fox sails through the air
atop his disintegrating car after a crash in the
Indianapolis 500 at the end of May. The
world's most famous IndyCar race was won
by Canadian Jacques Villeneuve, at 23 the
youngest driver ever to triumph in the event.

9621
An exciting moment in Orlando, Florida,
during an NBA basketball play-off game
between the Orlando Magics and the Boston
Celtics. Nick Anderson, playing for the
Magics, bounces up to the basket after a
breakaway pass which ended in a thunderous
dunk.

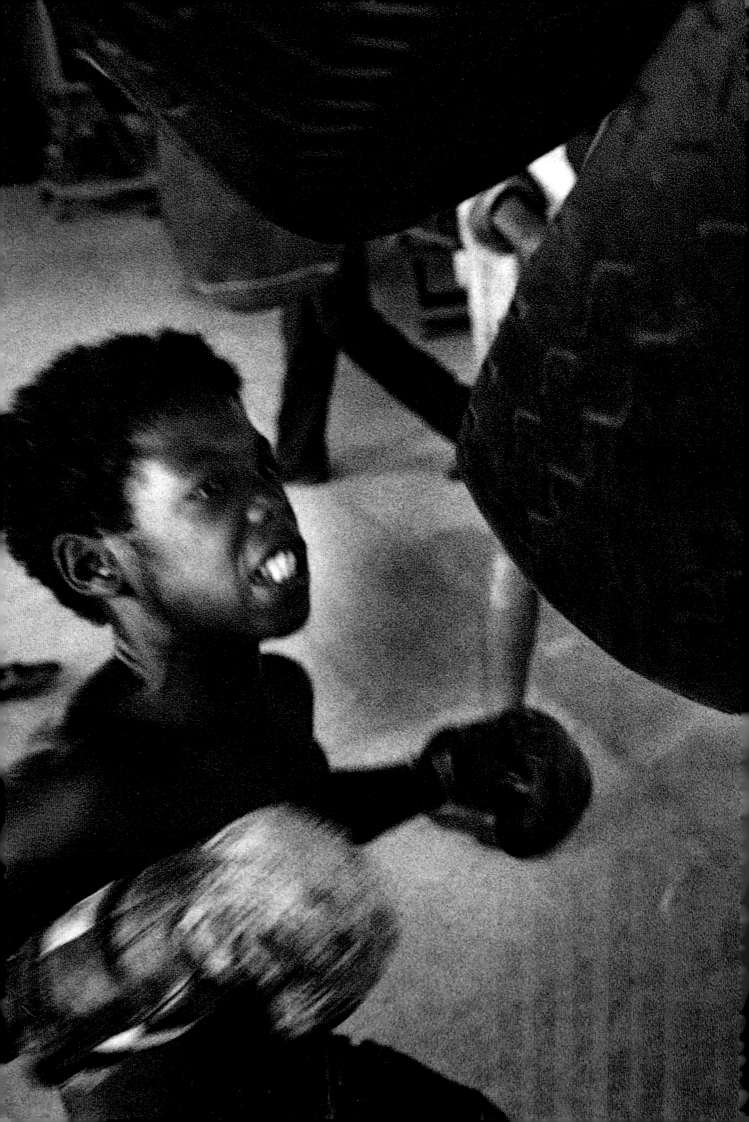

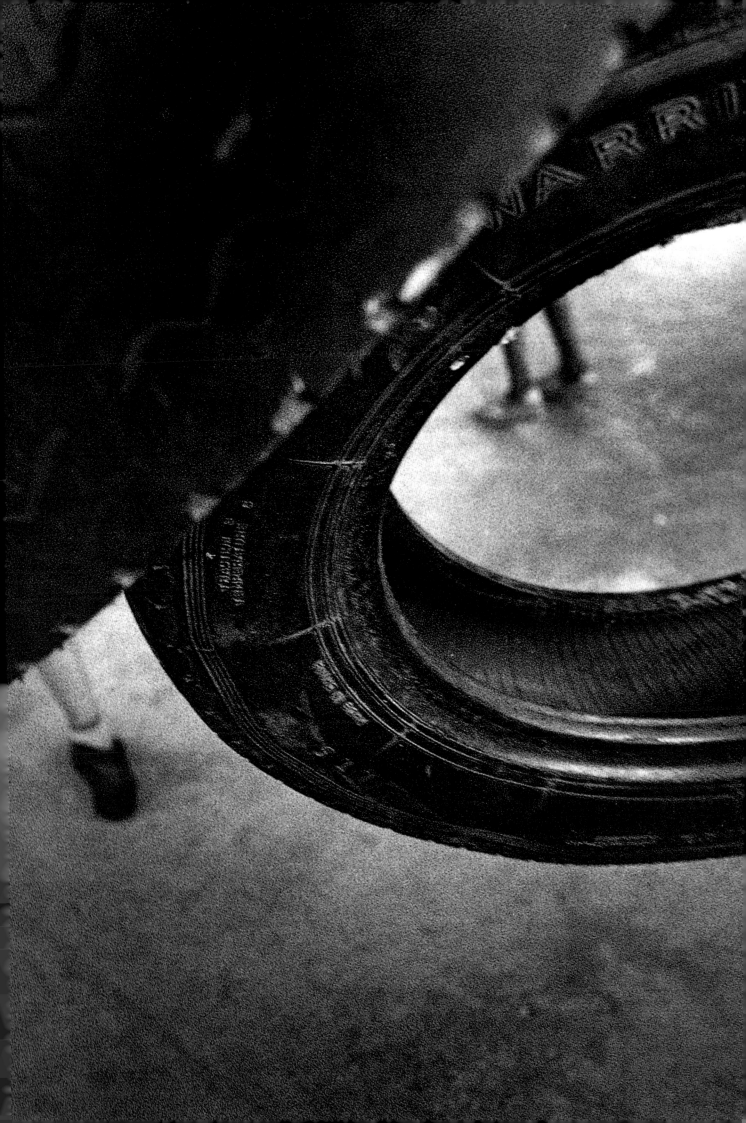

**STEPHAN
VANFLETEREN**
Belgium, Agence
Vu,
France

**THIRD PRIZE
STORIES**

9622

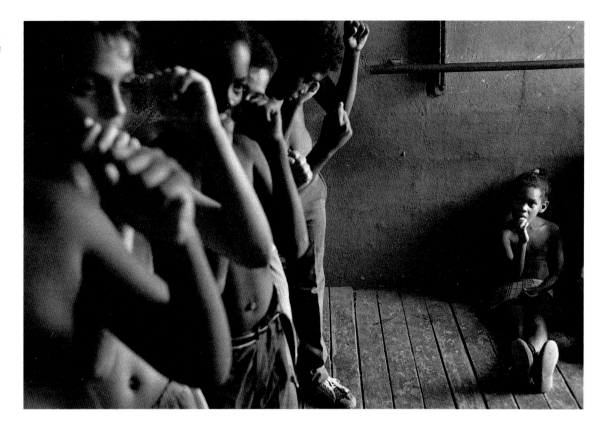

 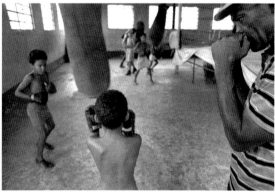

9622 (story starts on p. 44)
Blood, sweat and tears are the stuff of dreams in Cuba's boxing schools. Former champions – some of advancing years – teach young hopefuls the tricks of the trade in Havana's shabby sports halls in the hope of continuing the Caribbean island's tradition as an Olympic boxing nation. Some boys take up boxing when they're only four years old.

Overleaf: A budding boxer practices his punches on discarded car tires. This page: A young girl looks on in awe while training is in progress in a Havana suburb. The boys, in turn, watch their own heroes. Facing page: Warming up sessions and group shadow boxing classes are part of the daily routine.

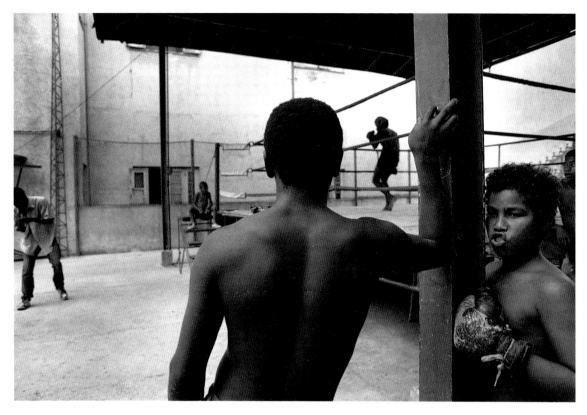

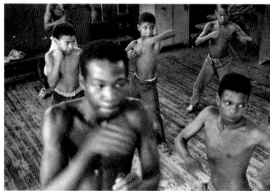

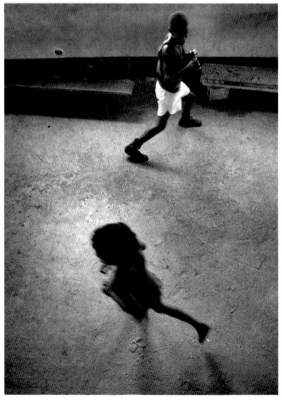

STEPHEN DUPONT
Australia,
Independent
Photographers
Group,
UK

**SECOND PRIZE
STORIES**

9623

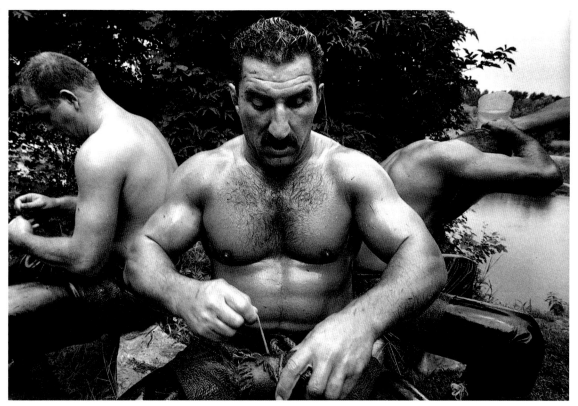

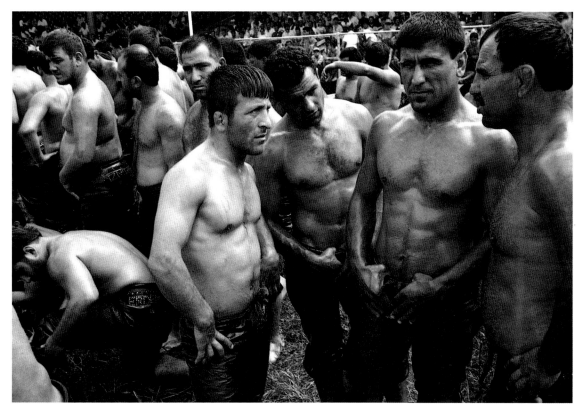

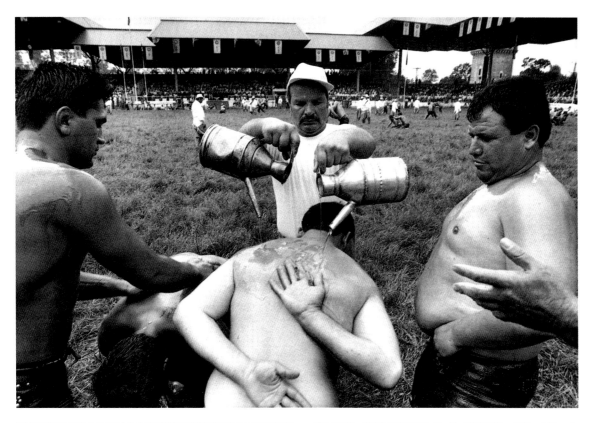

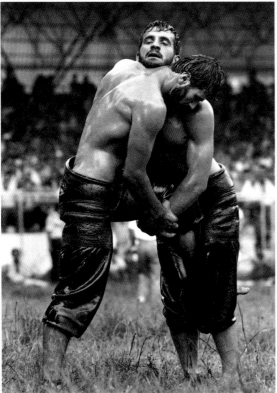

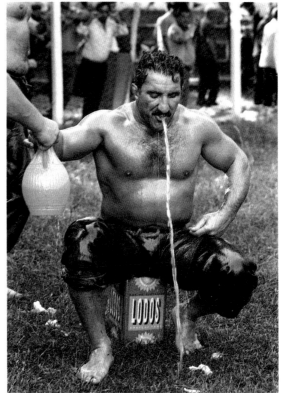

9623
Oil wrestling is a popular sport in Turkey. In order to make it impossible for their opponents to get a grip and bring them down, the wrestlers are covered in olive oil (top). Ahmet Tasci holds the title of Grand Champion. At top left, he is shown preparing for the Kirkpinar tournament in Edirne. Above, Tasci recovers during a break in the matches at Akbalik village. Above left: At Edirne, wrestlers cling to each other in utter exhaustion.

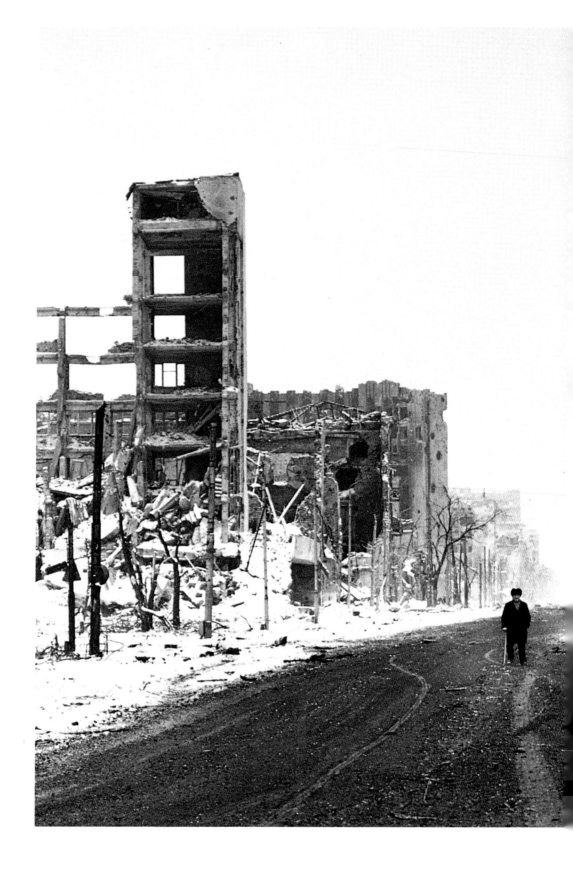

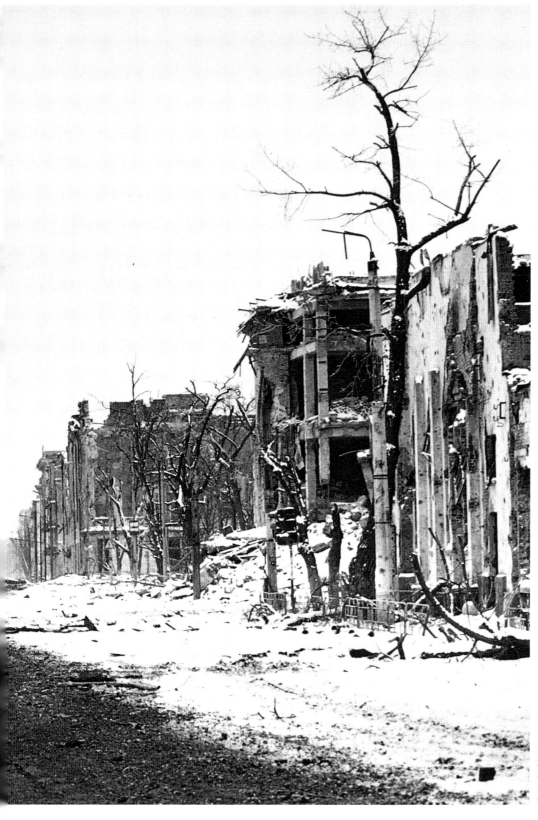

ANTHONY SUAU
Time Magazine,
USA

**SECOND PRIZE
SINGLES**

9624

9624
Early in 1995 persistent Russian bombing
and artillery fire reduced Grozny, the capital
of the Chechen Republic, to a ruined theater
of war in a matter of weeks. Russian troops
and Chechen separatists were still battling
over the city when this old man took a stroll
down a main road, risking death by sniper
fire.

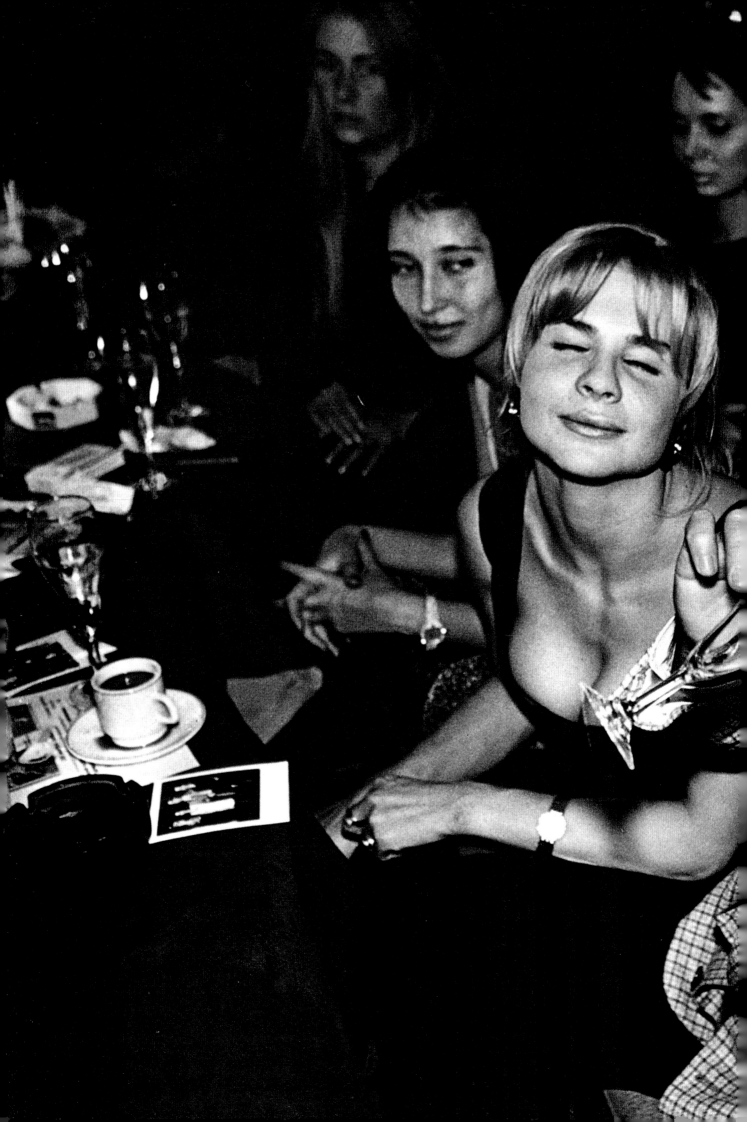

ANTHONY SUAU
The New York Times
Magazine,
USA

**FIRST PRIZE
STORIES**

9625

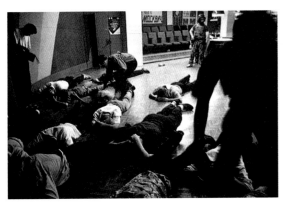

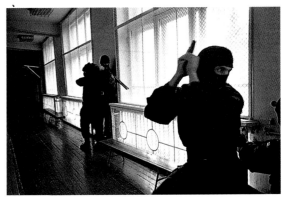

9625 (story starts on p. 52)
When the free market came to Russia, there were no laws to control it. The gap was filled by organized crime, which has its own strict rules. Those who break them have to pay the price. 'Razborkas' — meetings intended to settle disputes — often end in shootouts.

Overleaf and above left: Moscow's organized-crime police bursts into a pool hall during a razborka. Guns were confiscated and arrests made. Facing page, center: Two victims of a razborka are discovered at a garbage dump. Top: Hundreds are arrested at an Azeri marketplace in Moscow. Above right: Private security companies thrive in Russia. At top right, they practice protecting a businessman from gangsters. Bottom right: A high-ranking customs official has been gunned down in a Moscow street – another professional killing. Page 52: The glamorous side of business life at Moscow's Arliquino nightclub.

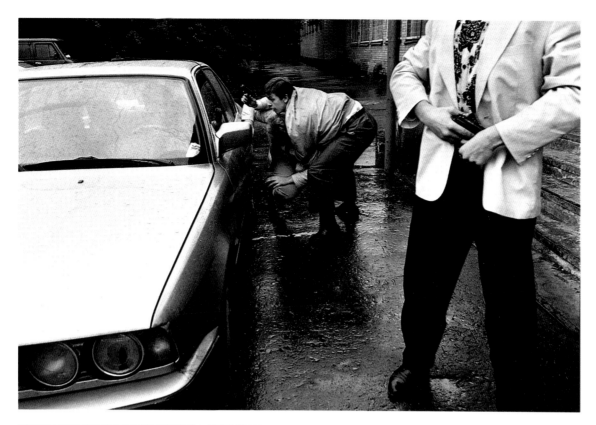

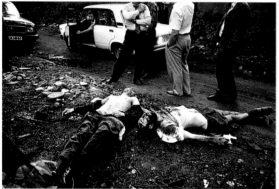

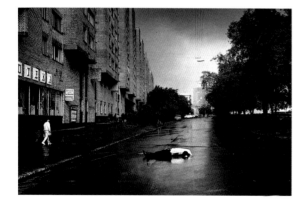

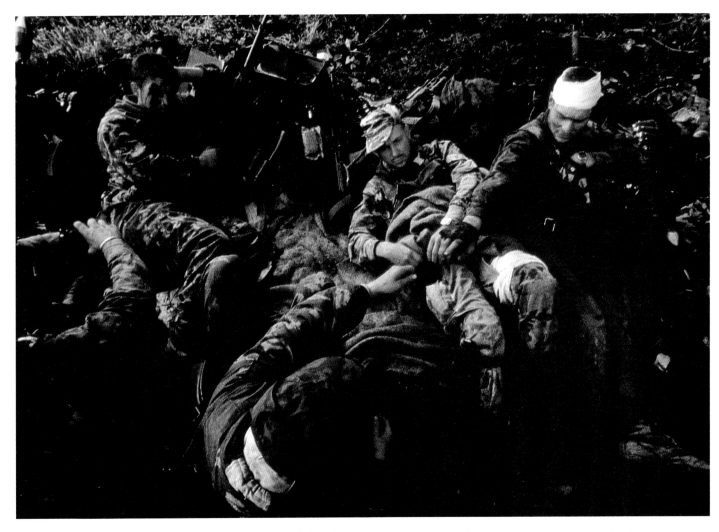

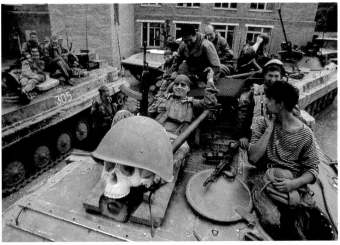 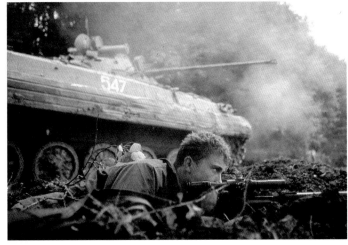

ERIC BOUVET
Le Figaro Magazine,
France

**THIRD PRIZE
STORIES**

9626

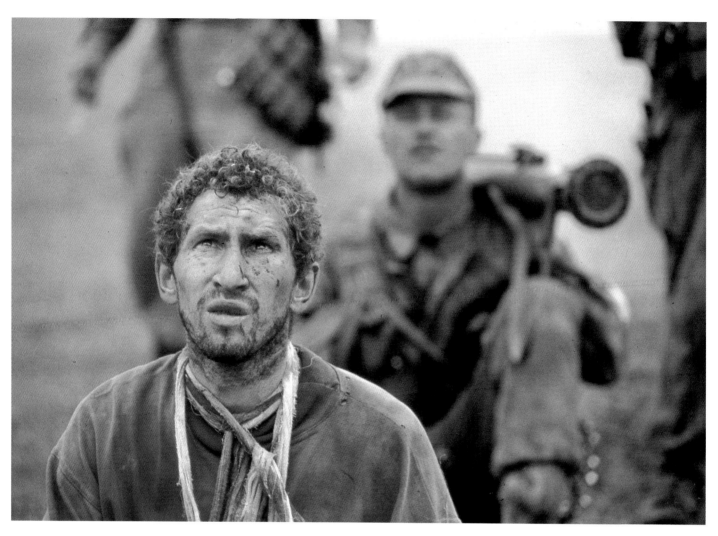

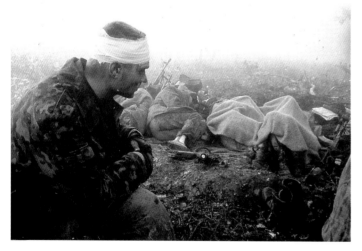

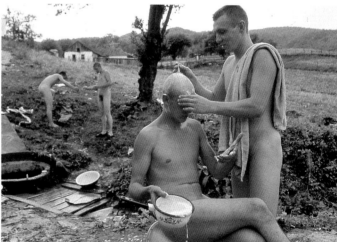

9626

For two weeks the photographer accompanied Russian special forces of infiltration and intelligence on their mission in Chechnya. Using night-glasses to see in the dark, they occupied strategic positions behind enemy lines. Villages were raided for food and subsequently burnt down. Chechen hostages were taken (top), interrogated under torture and then executed. Top left and above left:

The special forces suffered heavy losses: five dead and 25 injured out of a total of 60 men. Facing page, bottom: A skull taken from a school which sheltered rebels serves to amuse the Russians. At dawn a Chechen position is captured, sprayed with automatic weapons and finally blown up with a missile. Above: Time for a wash after 12 days and nights of fighting.

**JACQUES
LANGEVIN**
Sygma,
France

**THIRD PRIZE
SINGLES**

9627

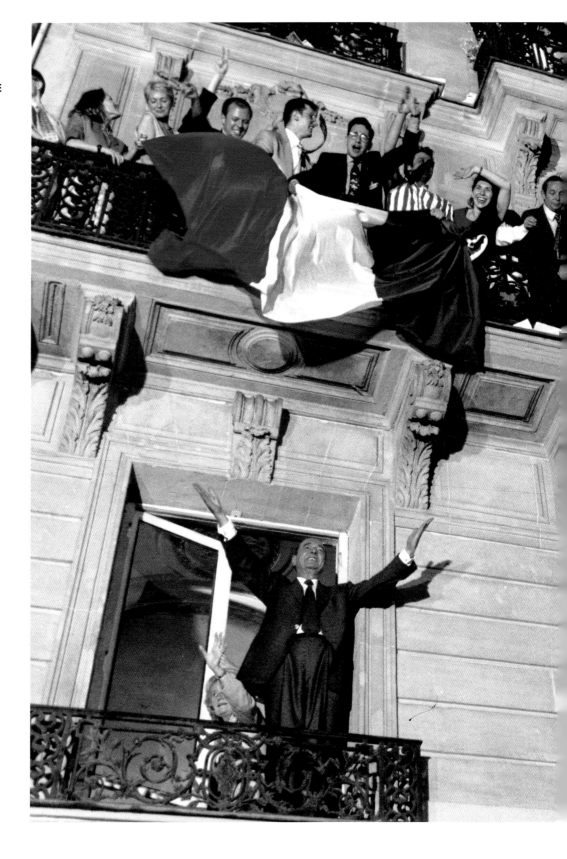

9627
Three times Jacques Chirac made a bid for
the presidency of France's Fifth Republic. His
first two attempts – in which he stood against
François Mitterrand – failed, but his third
succeeded. After narrowly beating socialist
candidate Lionel Jospin on May 7, the former
mayor of Paris appeared before a jubilant
crowd on the balcony of his Paris campaign
headquarters.

DAVID C. TURNLEY
Detroit Free Press/
Black Star
for Time Magazine,
USA

SECOND PRIZE STORIES

9628

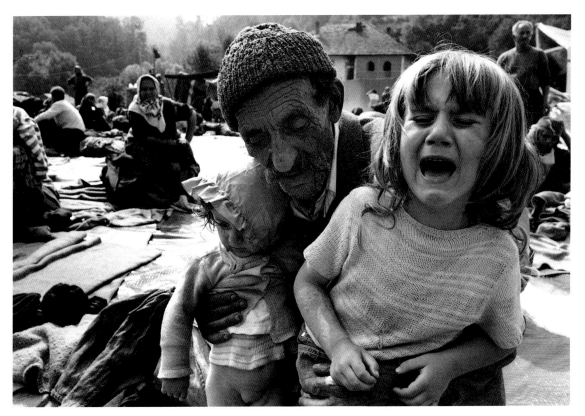

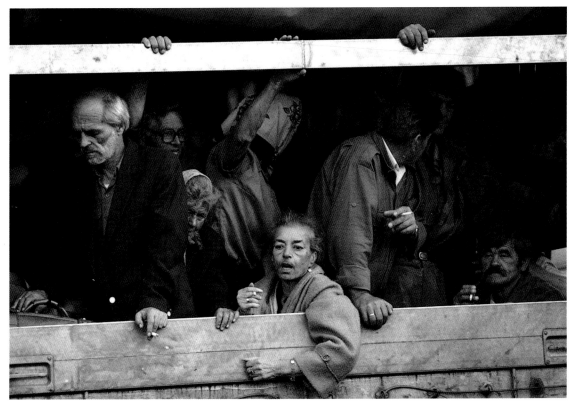

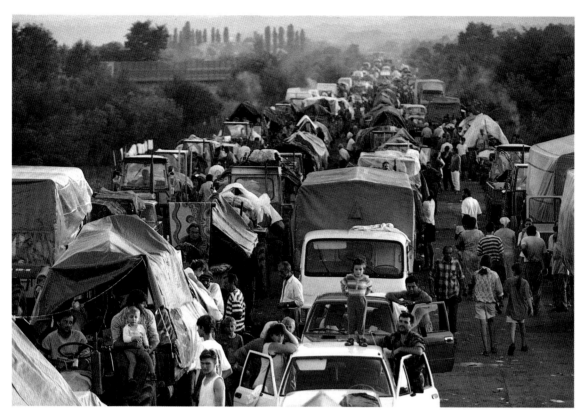

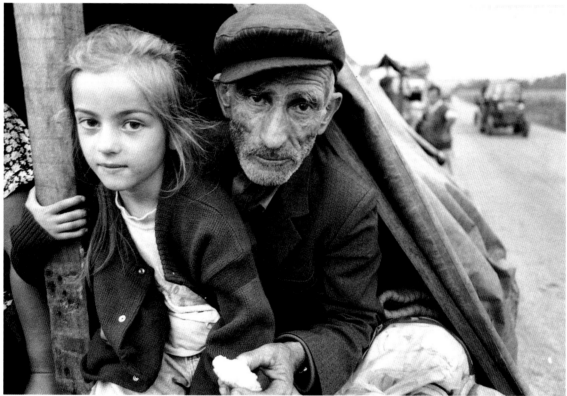

9628

In 1995 no ethnic group in Bosnia remained untouched by anguish and upheaval. The Serbian conquest of the enclaves of Srebrenica and Zepa – which underscored UN impotence to guarantee their safety – triggered a mass exodus to the last remaining Muslim strongholds. Faced with a Croatian offensive, Serb inhabitants of the Krajina region also packed into trucks and tractors in an attempt to reach Serbia (bottom left and top), and many Bosnian Croats sought refuge in Croatia. Top left and above: With thousands of younger people killed and missing, aged grandfathers often had to take care of small children (story continues).

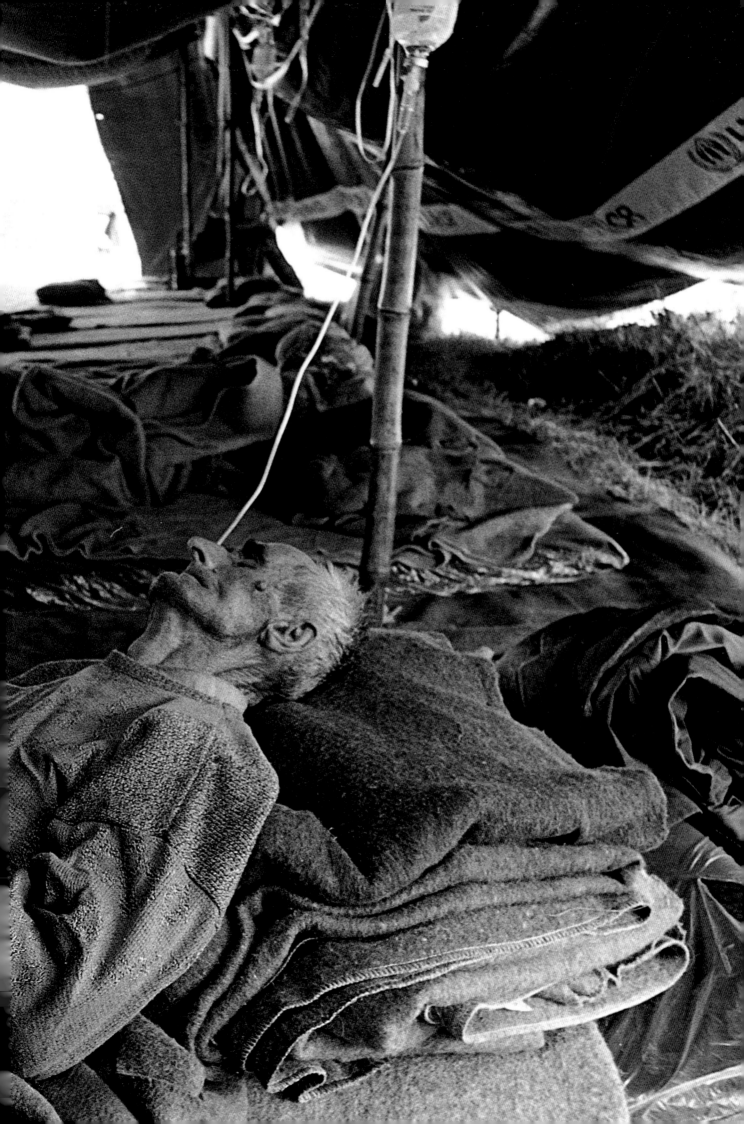

9628 (continued)
Overleaf: Driven from his home town of Zepa
by conquering Serbs, this aged Muslim had
to walk ten kilometers to Tuzla before collap-
sing in a state of dehydration and exhaustion.
Above: A similar fate befell this woman from
Srebrenica, who sits quietly sobbing outside
a refugee shelter in Tuzla.

Photo: Johan Hellström

DAVID TURNLEY (40) has covered interna-
tional news for The Detroit Free Press since
1982. His pictures are distributed by Black
Star. He has won the World Press Photo of
the Year twice; his other awards include the
Pulitzer Prize and the Robert Capa Gold

Medal. Turnley has published four mono-
graphs. With his twin brother Peter – a pho-
tographer with Newsweek – he will have a
retrospective of their work at the International
Center of Photography in New York in June
1996.

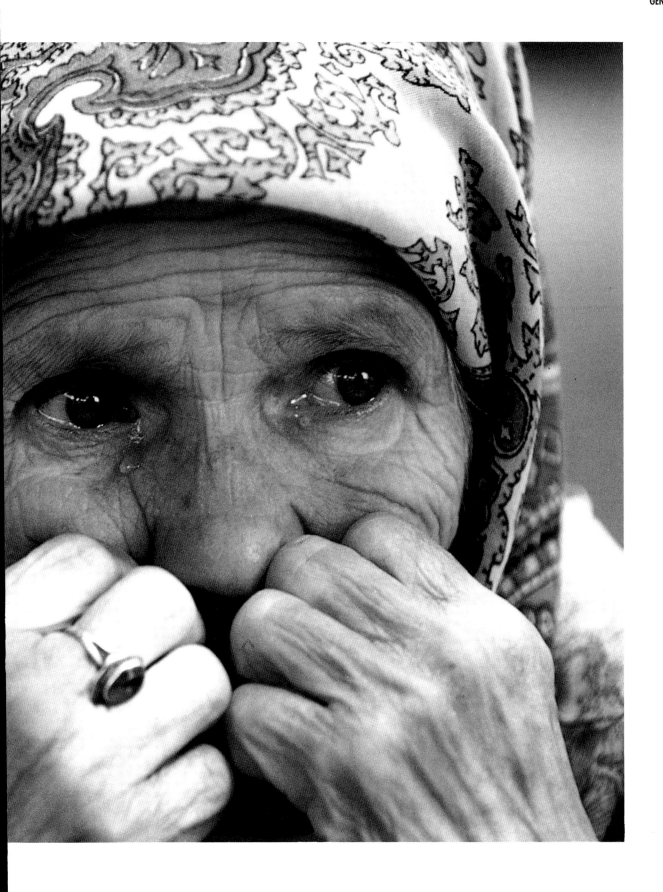

FOUAD ELKOURY
Lebanon, Rapho,
France

**HONORABLE
MENTION
STORIES**

9629

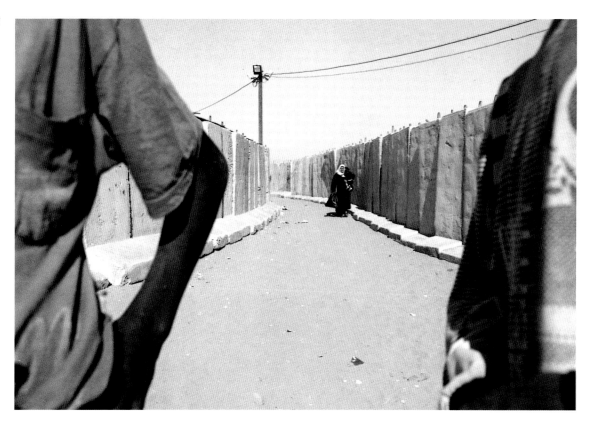

9629
Shot over a two-year period after the signing of the first Israeli-Palestinian accord in September 1993, this reportage set out to give insight into the lives of the Palestinians in the Gaza Strip, Jerusalem and Rafah (a town on the Egyptian border) without reference to their relations with the Israelis. Facing page, top: People entering Gaza from Israel have to cover approximately one kilometer on foot. Bottom: Local youngsters use this cemetery in the Shajiyya quarter of Gaza City as their playground. Top: A boy daydreams in front of a mirror in Rafah. Bottom: A Gaza fisherman goes about his daily business.

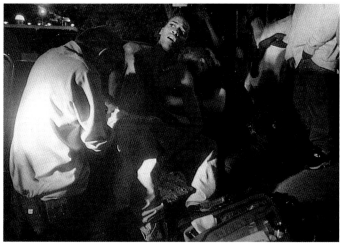

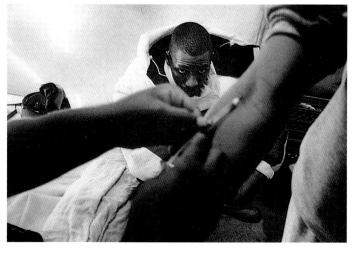

**ANDRE
LAMBERTSON**
The Baltimore Sun,
USA

**HONORABLE
MENTION
STORIES**

9630

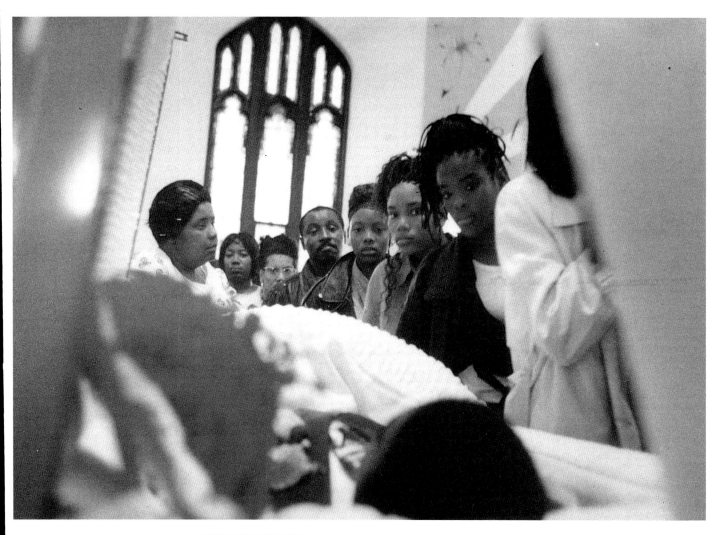

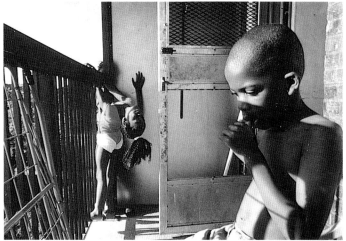

9630

America's inner cities continue to struggle with crime, drugs and violence. In Baltimore, one of every three children lives in poverty. More than half of all black kids are raised by a single mother, who is often a drug addict or an alcoholic. Some turn to street gangs as a surrogate family, while others withdraw into a world of their own. Facing page, top: Three 13-year-olds are arrested for car theft.

Bottom: A teenager gets medical attention after being shot in the back. A heroin addict eyes the needle he renounced for 60 days. Then he relapsed. Above, another addict and his six-year-old son wake up to a new day. Top: Friends line up to say farewell to Rico, who died at 16. Above left: Children escape the heat of summer on their balcony.

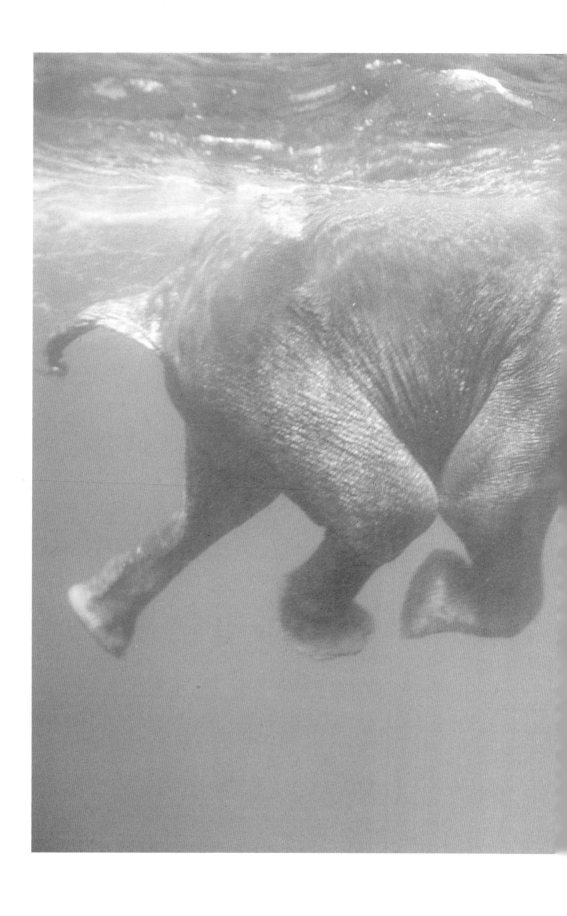

NATURE AND THE ENVIRONMENT

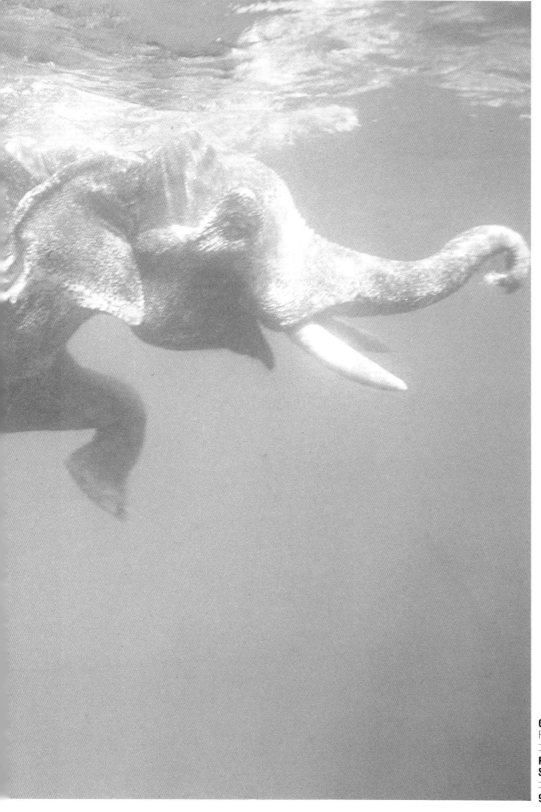

OLIVIER BLAISE
France

**FIRST PRIZE
SINGLES**

9631

9631

Elephants can swim up to 20 miles a day. Their trunks are ideally suited to be used as snorkels. Pictured between two of the Andaman Islands in the Bay of Bengal, this particular elephant is on his way to work. He is employed in the timber trade, carrying logs along tracks in the jungle. Since local residents discovered the pachyderm's talent to travel through water, it has been put to good use. This elephant was born in captivity and belongs to a landowner on the island of Havelock. When he is about 60 years old, he will be retired and given the freedom to roam his owner's estate or a special reservation elsewhere in the Andamans.

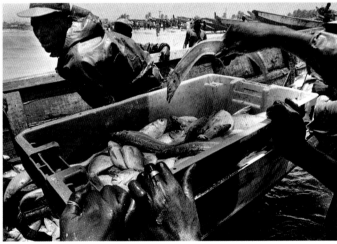

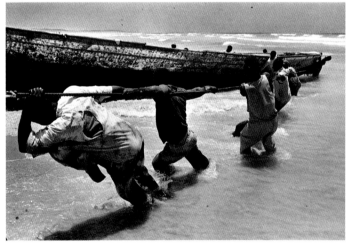

GIDEON MENDEL
South Africa,
Network
Photographers,
UK for Greenpeace
Magazine,
Germany

**SECOND PRIZE
STORIES**

9632

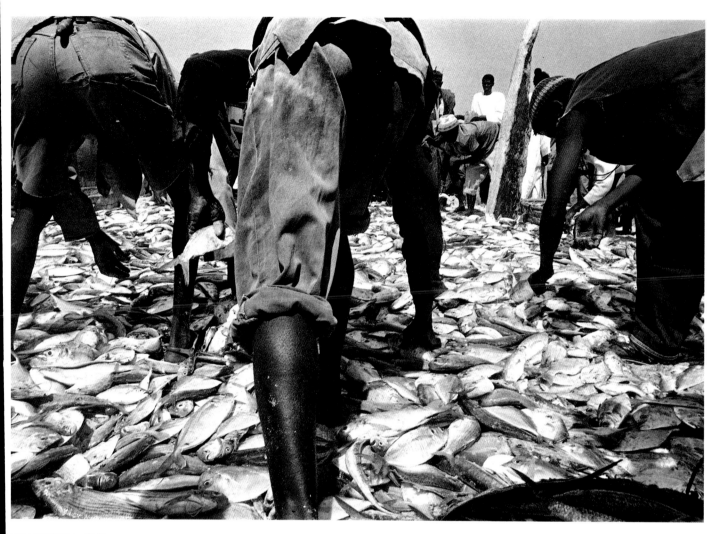

9632
Kayar, a fishing village on the coast of Senegal, West Africa, is dependent for its livelihood on the rich fishing grounds offshore. Everything that is caught is used: the fish is eaten fresh, smoked or dried, while the heads are used as chicken feed. A deal struck recently between the government of Senegal and the European Union, giving EU trawlers access to these seas, threatens to upset the traditional, sustainable village economy. The pictures show boats – which go fishing in pairs – out at sea, getting beached and being used for children's games. The catch is sorted by hand on the beach. Above left: Lion dance in Kayar's marketplace. The tradition dates back to the days when lions roamed the area around the village.

**MICHEL
DENIS-HUOT**
France

9633

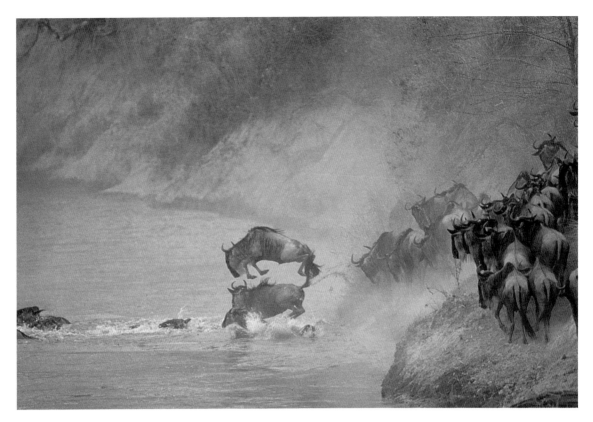

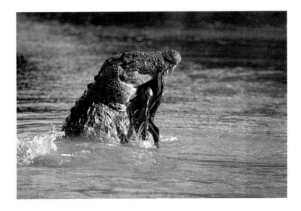

9633
The annual migration of gnus across the Mara river in Kenya's Masai nature reserve presents an impressive spectacle. Undaunted, the heavy animals jump into the water, often injuring themselves in the process (top). As they scramble up the other bank in large numbers after swimming across, many young calves are separated from their mothers and rejected by the other females.

There are also other dangers, such as crocodiles lurking in the murky water (above). For some of them, this is their only chance to feed all year. But that is no problem for grown crocodiles: they can survive without food for up to two years.

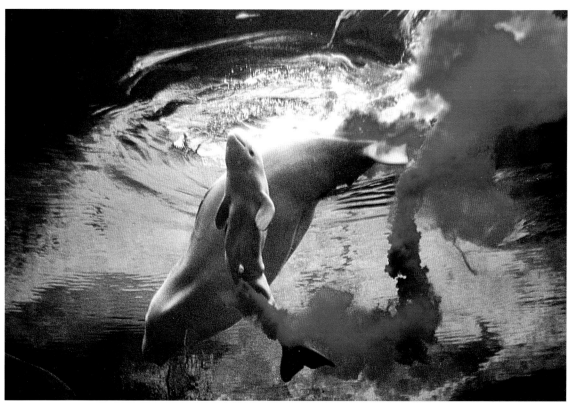

JEFF VINNICK
Reuters
News Pictures,
Canada

**SECOND PRIZE
SINGLES**

9634

BRYAN PATRICK
The Sacramento
Bee,
USA

**THIRD PRIZE
SINGLES**

9635

9634
Coming up for air. Seconds after being born at the Vancouver Aquarium, a baby beluga whale heads for the surface to draw breath. The healthy calf was named Qila and weighed in at just over 100 pounds. Only two dozen belugas have ever been born in captivity. After a few years they lose their gray pigmentation – hence their other name: the white whale.

9635
Watched by visitors to Sacramento Zoo in California, a nyala antelope gives birth for the first time. The name nyala comes from the Bantu, the language spoken on the southern African savannah where the species was first discovered. The newborn's English name is Nicholas.

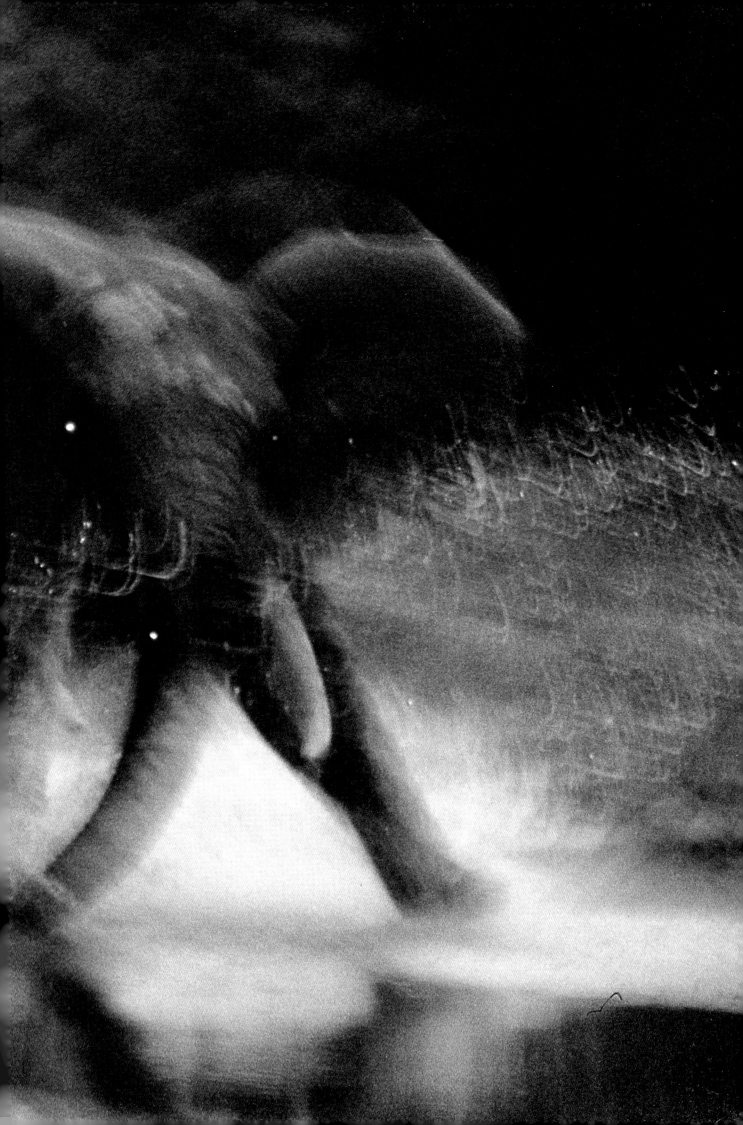

MICHAEL NICHOLS
National Geographic Magazine,
USA

FIRST PRIZE STORIES

9636

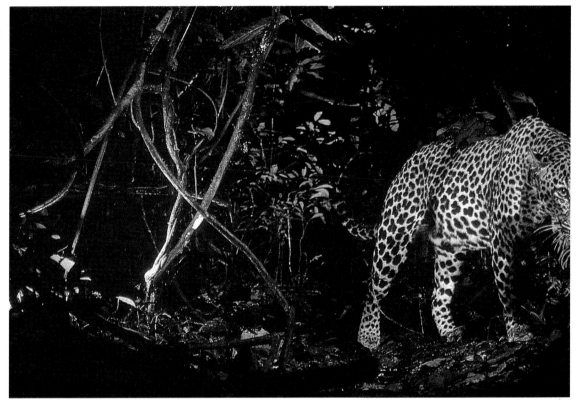

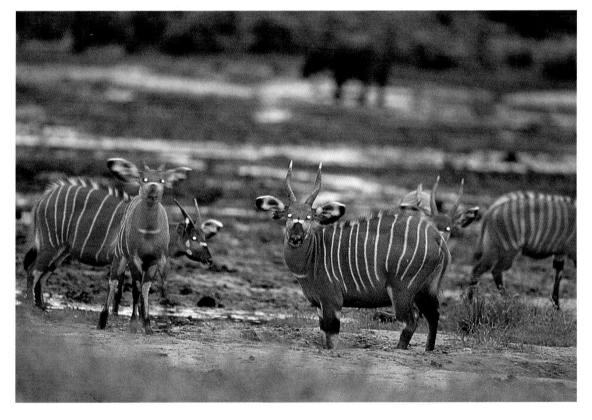

9636 (story starts on p. 78)
In 1993 a carefully planned expedition ventured into the depths of central Africa to the Ndoki river, an almost undisturbed area supporting Pygmies and abundant wildlife. After more than a year they returned with this reportage. Overleaf: A forest elephant stands her ground. Female elephants are more likely to charge than males. Top: A leopard pads silently through the forest in search of a meal.

Above: Bongo, the largest forest antelope, venture into a clearing after dusk. The Pygmies (facing page) are the world's shortest people. Top: Babenzélé Pygmies gaze up in disbelief at an expedition member using nylon climbing ropes. Right and far right: The Pygmies have perfected a technique of collecting honey by stunning bees with smoke.

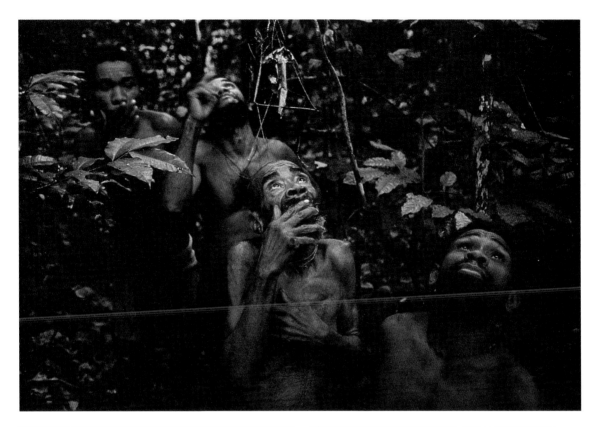

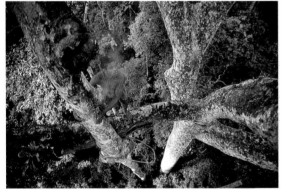

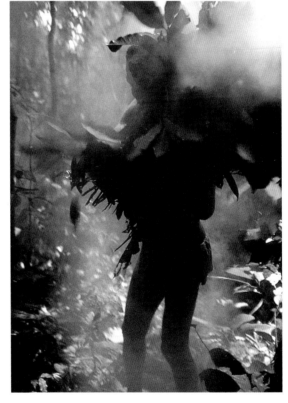

DOD MILLER
Network
Photographers,
UK

**THIRD PRIZE
STORIES**

9637

9637

The rights of non-smokers are increasingly recognized, particularly in the Western world. A European Union directive stipulates that if rest areas are provided in the workplace, there should be provision for non-smokers. As a result, smokers often have no alternative but to go outdoors to indulge their habit. Rain or shine, they can be seen alone or in small groups taking a smoking break in doorways, on rooftops and balconies. In London, where this reportage was shot, smokers have it relatively easy. There are no anti-smoking laws in Britain, but the government encourages companies to implement a smoking policy.

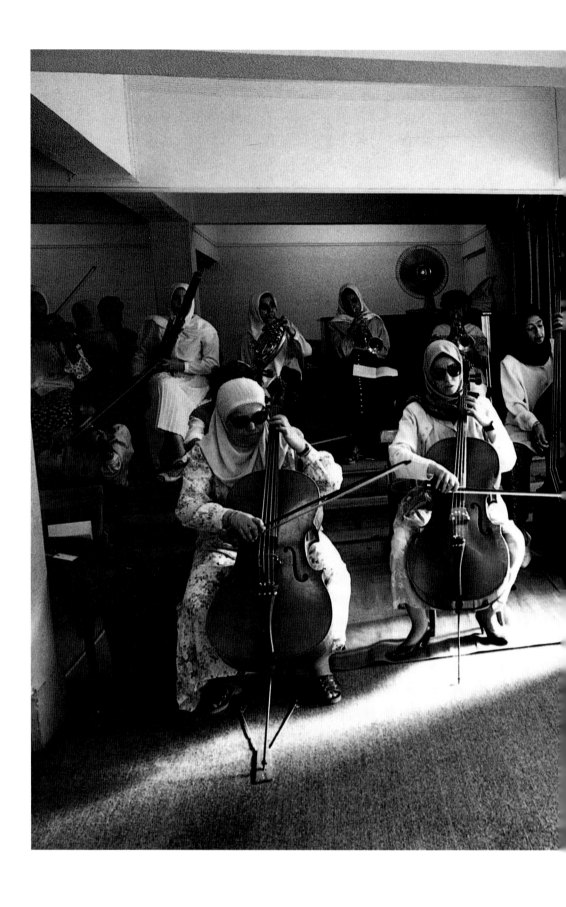

LORI GRINKER
Contact Press
Images
for Natural History
Magazine,
USA

**FIRST PRIZE
STORIES**

9638

9638
This orchestra is the pride and joy of Al-Nour wal Amal (light and hope), a center for the blind in Cairo. Eighty girls and women live at the center, which was founded by a wealthy landowner's daughter in 1954, with dozens more commuting every day. Besides a full school curriculum, the women's education includes handicrafts, cooking and home economics.

The musical program started in the 1970s has produced two orchestras of about 35 members each. The main orchestra performs both in Egypt and abroad, while a training ensemble of younger girls plays mostly for school audiences. Above: Some of the women are able to discern vague shapes and colors. Wearing sunglasses helps them concentrate (story continues).

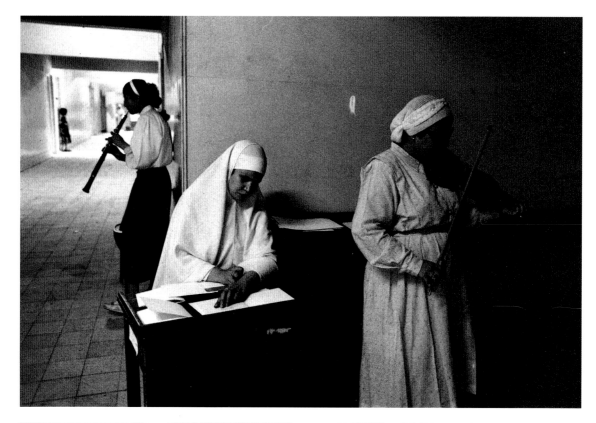

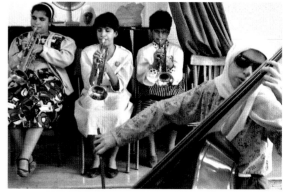

9638 (continued)

Top: Undisturbed by the women practicing around her, Sherifa Fathi prepares the parts for a new piece. She teaches Arabic and music at primary school level. Like the cellist shown above, she uses Braille notation. The system invented by Louis Braille – a blind musician himself – can represent all elements of a musical score. Above right: During a rehearsal of Dvorak's Slavonic Dance in G Minor, three women keep their trumpets poised on their lips while listening to instructions from maestro Abu el-Aid. Once the musicians have memorized their parts, the maestro runs the rehearsals, marking time by slapping the handle of a fly swatter on his desk (facing page, top). Bottom: French horn players relax during a break.

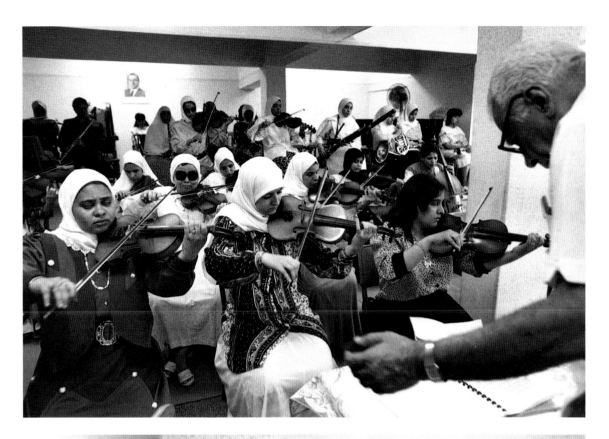

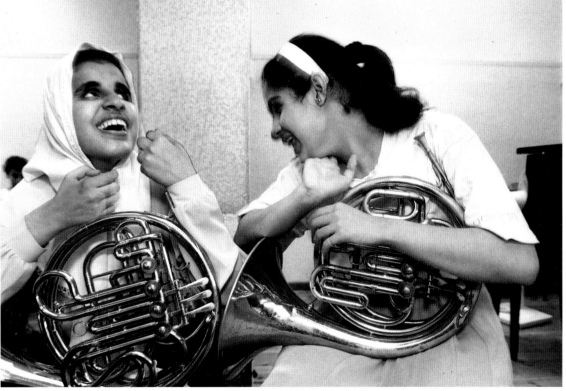

NANCY ELLISON
Sygma
for Life Magazine/
American
Ballet Theatre,
USA

**THIRD PRIZE
STORIES**

9639

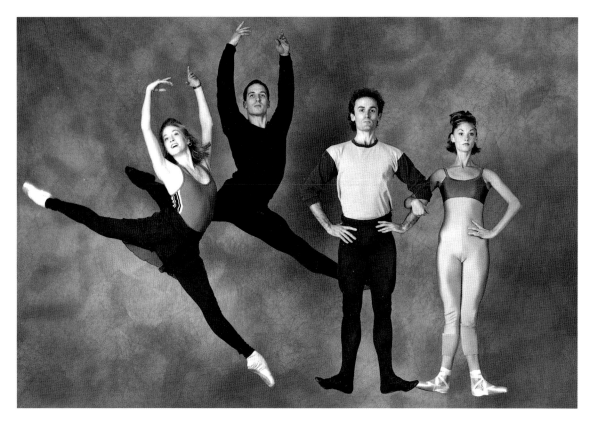

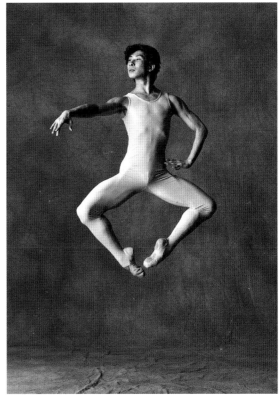

9639

It took the photographer almost a year to shoot the material for a souvenir book of portraits for the American Ballet Theatre in New York. Locations included the company's Broadway studios and the Lincoln Center. These pictures were made at the Metropolitan Opera, where a wardrobe room was converted into a studio. Principal dancers such as Paloma Herera (above left) were asked to wear costumes and create characters, while soloists – who rank lower in the ballet hierarchy – wore their own clothes. From far left, the soloists shown are Keith Roberts, Robert Wallace, Veronica Lynn (top) and Naoya Kojima (above). Members of the Corps de Ballet (top left) were encouraged to create their own mood for each group picture.

JÜRGEN GEBHARDT
Stern Magazine,
Germany

**SECOND PRIZE
SINGLES**

9640

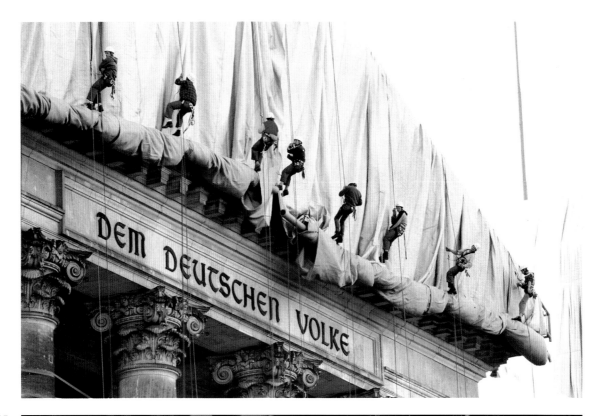

WOLFGANG VOLZ
Germany

9641

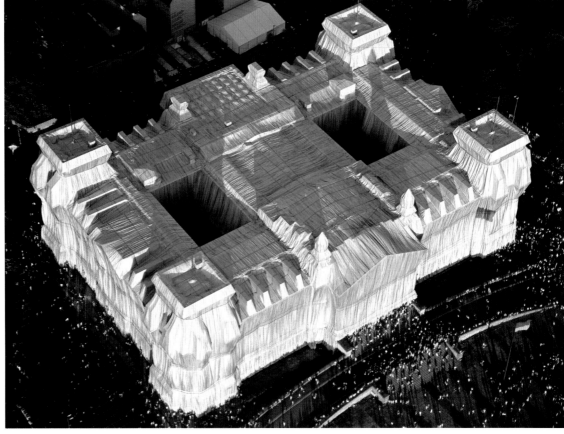

9640
Wrapping up the Reichstag. After 20-odd years of cherishing his dream of cloaking the former Third Reich headquarters in Berlin in silver fabric, Bulgarian artist Christo made it come true. Spending millions of his own money, he directed a team of more than 200 who took seven days to cover the monumental neo-Renaissance building in draperies.

9641
Aerial view of the Reichstag building after it had disappeared under 100,000 square meters of fabric. The effect was stunning, silencing most critics of Christo's controversial project. Many thousands came to see the cloaked monument. After the wrapping had been removed, preparations got underway to receive the German parliament in a few years' time.

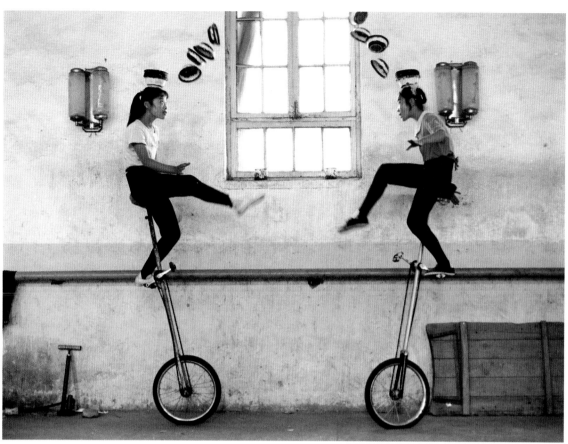

LI NAN
Newsphoto Weekly,
People's Republic
of China

**FIRST PRIZE
SINGLES**

9642

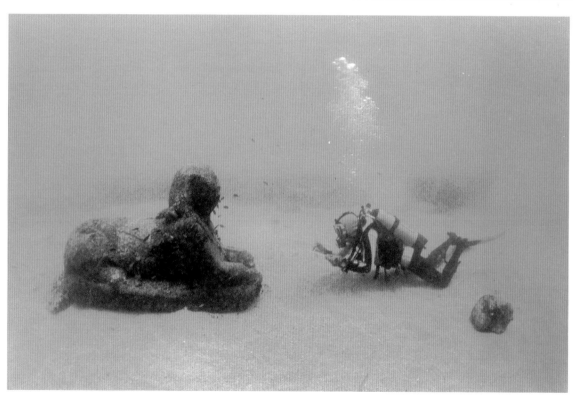

**STEPHANE
COMPOINT**
Sygma,
France

**THIRD PRIZE
SINGLES**

9643

9642
Concentration is the name of the game at the renowned children's acrobatics school of Liaocheng in China's Shandong province. Every morning at 5:30 am, 33 children aged between six and 15 start their daily ten-hour training program. They are spurred on by teachers who tell them that one minute's performance takes ten years of practice.

9643
Off the coast of Alexandria, Egypt, a diver notes the location of a sphinx submerged in seven meters of water. Thought to have been thrown there by an earthquake long ago, the two-ton colossus was discovered near the site of Alexandria's legendary lighthouse, one of the seven wonders of the ancient world. A French archaeological expedition also found remains of the lighthouse itself.

ZENG NIAN
People's Republic
of China,
Contact Press
Images,
France

**SECOND PRIZE
STORIES**

9644

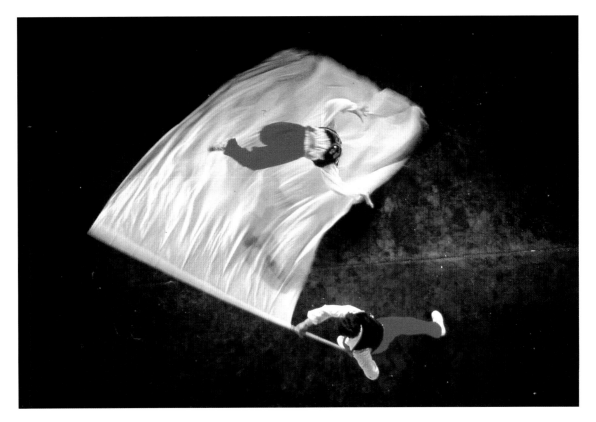

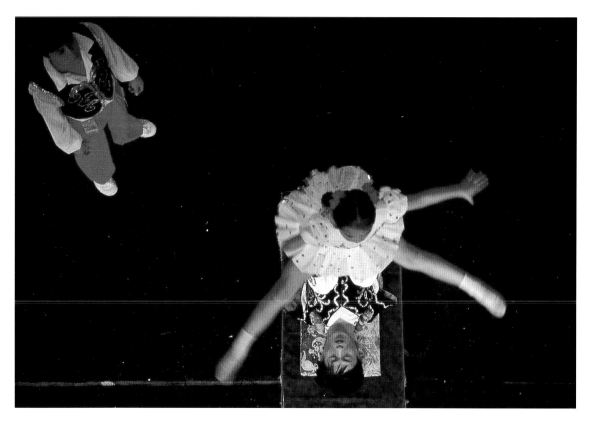

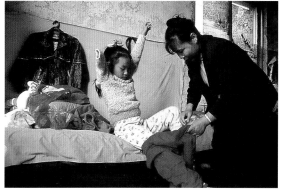

9644
Liu Xigui, a Chinese millionaire, created this group of disabled acrobats five years ago. The troupe consists of 11 boys and five girls, aged between seven and 23. Six of the young acrobats are mute, two have growth defects, and seven have only one arm or one leg.

Liu Xigui's goddaughter is the only member of the group without physical disabilities. When they are not on tour, the youngsters live at a specially equipped house in Manchuria, where they are trained by retired acrobats.

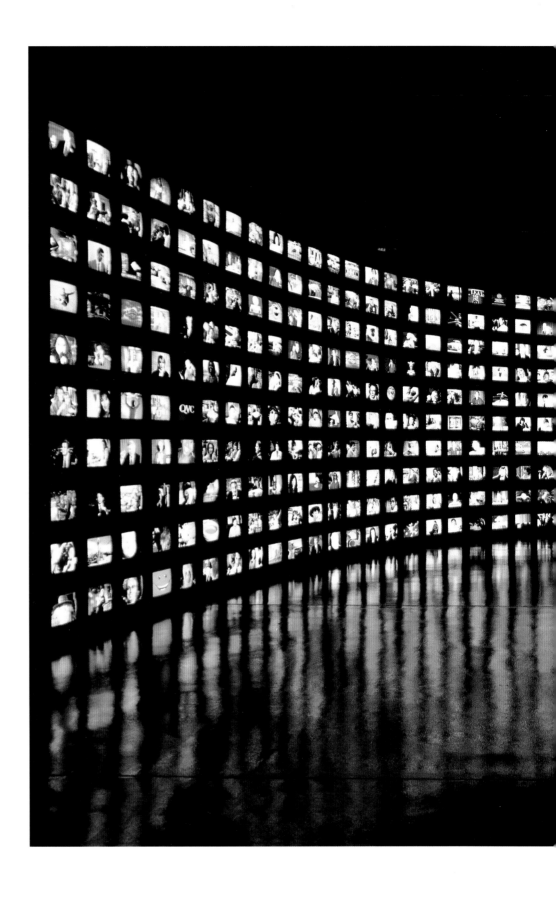

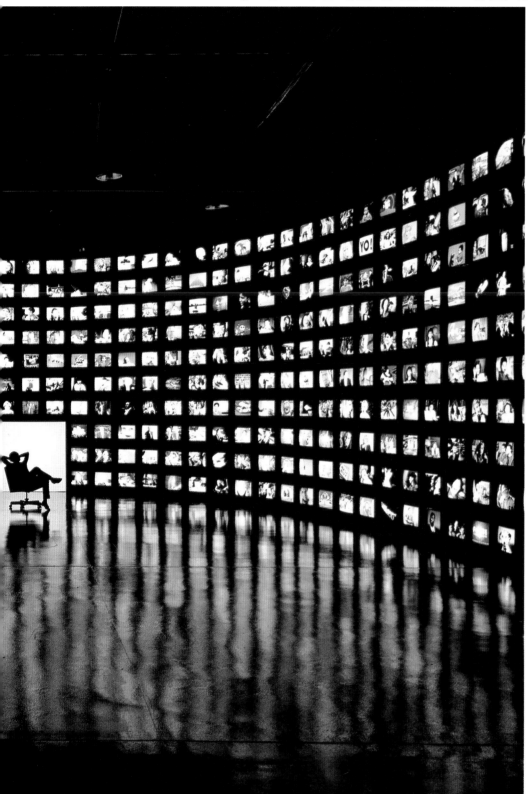

LOUIE PSIHOYOS
Matrix for National
Geographic
Magazine,
USA

**FIRST PRIZE
SINGLES**

9645

9645
Television's super-highway: this wall of 500 screens, showing 500 different images, served to symbolize the information revolution which – as the millennium approaches – affects everyone's daily lives. The electronic screen has an uncanny power to mesmerize. Today, young Americans spend as much time in front of a television as in a classroom, with the average adult watching over 30 hours every week. The technology is in place to transmit at least 500 channels by cable. The photographer, who specializes in complex assignments, designed a studio with 100 screens, which he photographed five times. The floor was covered with high-gloss paint for maximum reflection.

MANFRED LINKE
Laif Photos &
Reportagen,
Germany

**SECOND PRIZE
STORIES**

9646

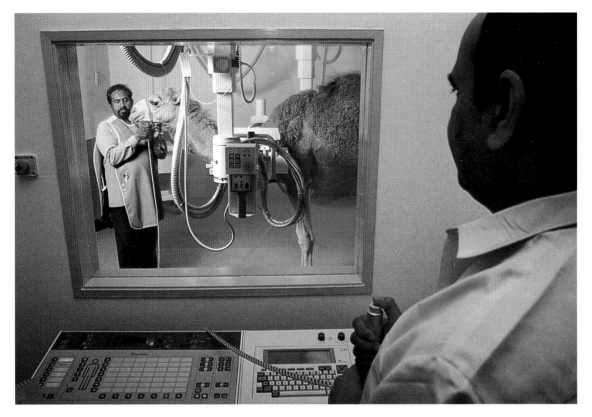

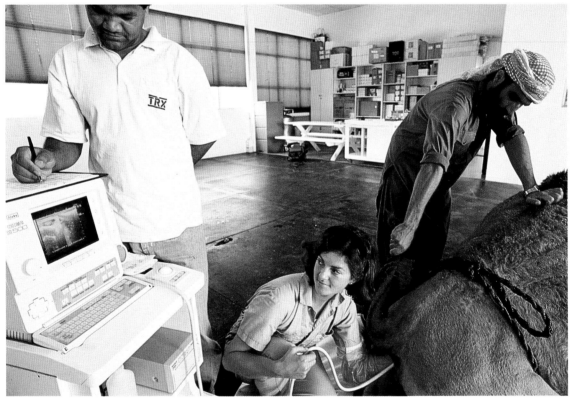

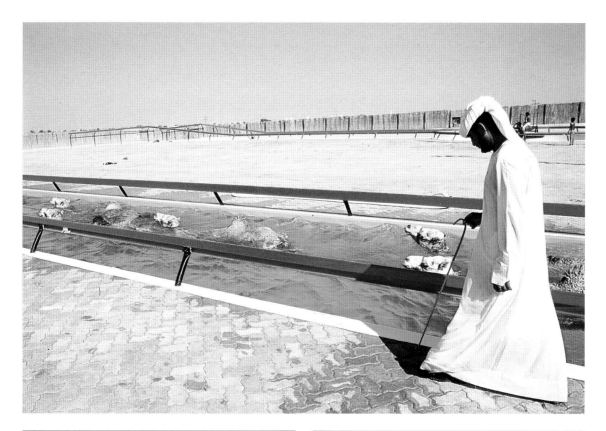

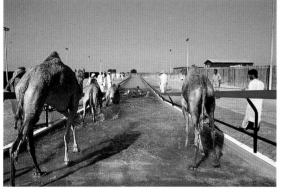

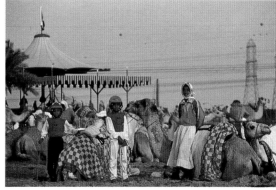

9646
Dubai's clinic-cum-research center for camels is unique in the world. Sheikh Mohammed, Crown Prince of the Emirate, indulged his passion for the Arab tradition of camel racing by founding this high-tech center, which is run by German scientists. The sheikh owns some 5,000 racing camels, valued up to US$3.5 million each, on which he is said to spend over US$45 million a year.

Facing page: Window on the clinic's X-ray room. Before artificial insemination a camel's womb is examined at the 'embryo farm'.
Above: The swimming pool is used for both physiotherapy and fitness training. In the enclosure child jockeys wait for the race to start.

**PATRICK
LANDMANN**
Arenok Presse
for Geo Magazine,
France

**FIRST PRIZE
STORIES**

9647

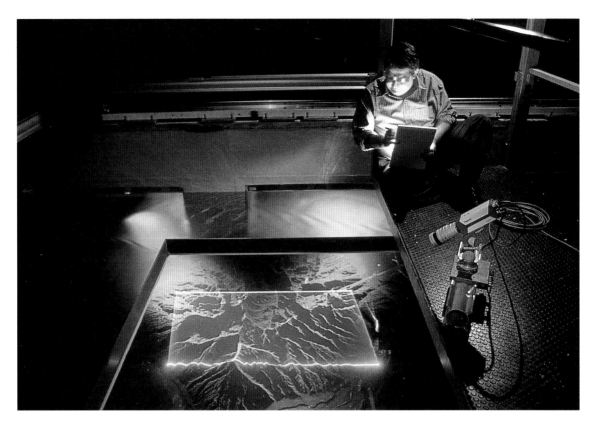

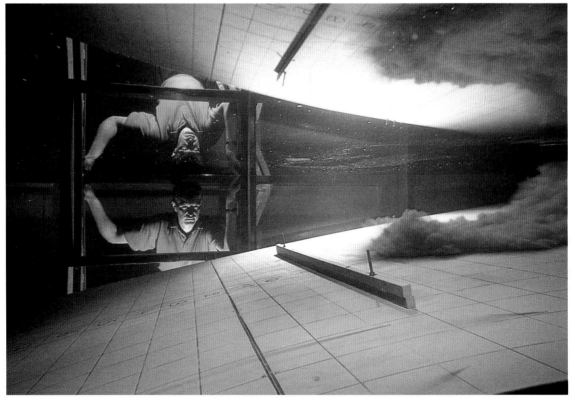

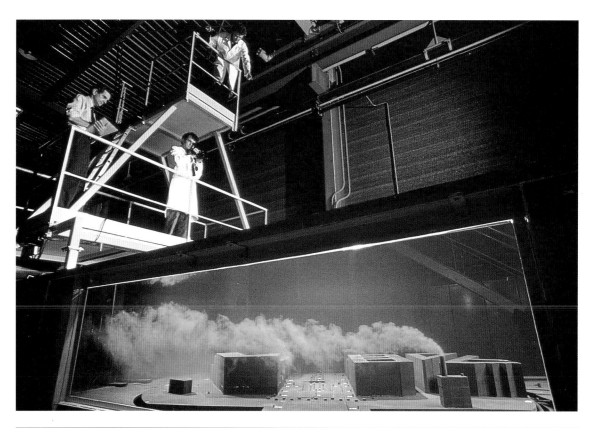

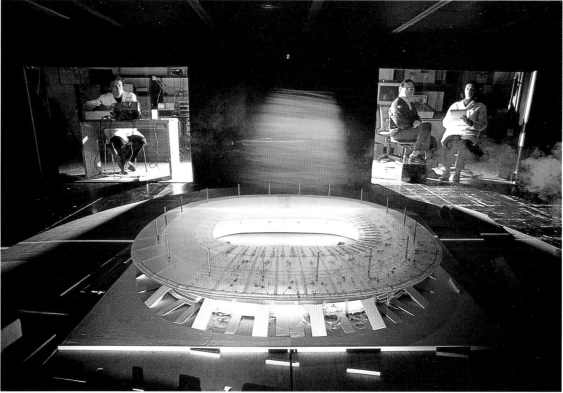

9647
Although virtual reality and computer simulation have replaced many physical tests, scale models are sometimes still the preferred option. In the French cities of Grenoble, Toulouse and Nantes such tests are carried out under strictly controlled conditions. Facing page, top: Scientists measure wind turbulence at Tahiti's airport. Bottom: A precise underwater simulation enables researchers to establish the correct dimensions for a dike to stop avalanches. This page, top: Lab technicians use a submerged model of an urban site to study the impact of pollutants on the environment. Bottom: The effect of wind on the roof of Paris' new sports stadium is measured as part of a wide-ranging test program.

**PATRICK
LANDMANN**
Arenok Presse
for Geo Magazine,
France

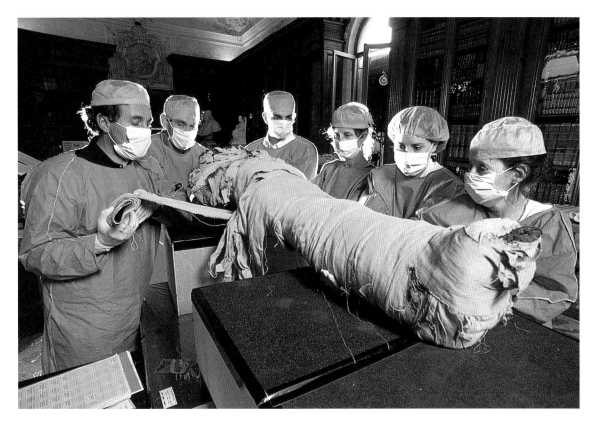

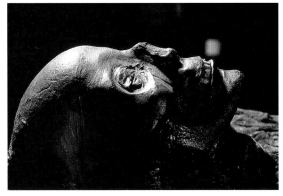

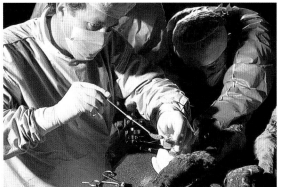

9648
Chemists, biologists, botanists and geolo-
gists use the latest techniques to extract
information from Egyptian mummies. In 1825
an Armenian adventurer who became Egypt's
Minister of Finance presented a mummy to
the Monastery of San Lazzaro in Venice.
These 3,500-year-old remains of a high-
ranking official or priest have become the
subject of intensive study.

This page, top: The monastery is an ancient
center of learning. Stripped of its wrappings,
the mummy has been laid out in the library.
Above left: A researcher takes a sample of the
sarcophagus which may enable her to estab-
lish the provenance of the tree of which it was
made, and thus, hopefully, of the mummy.

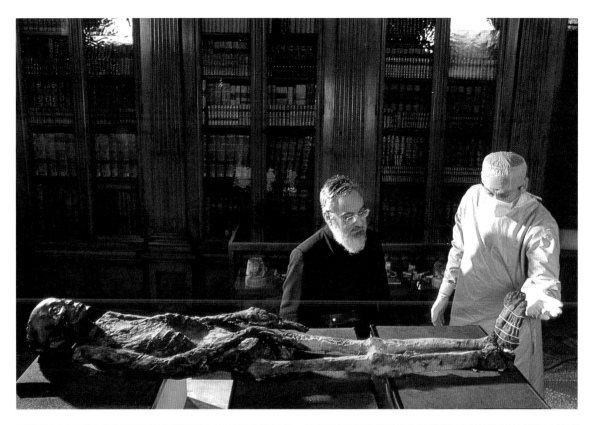

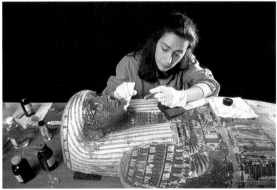

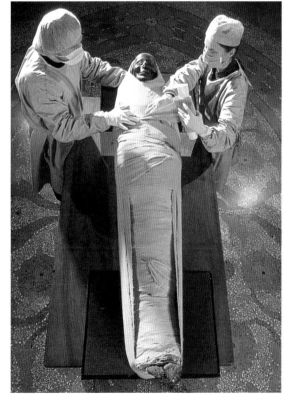

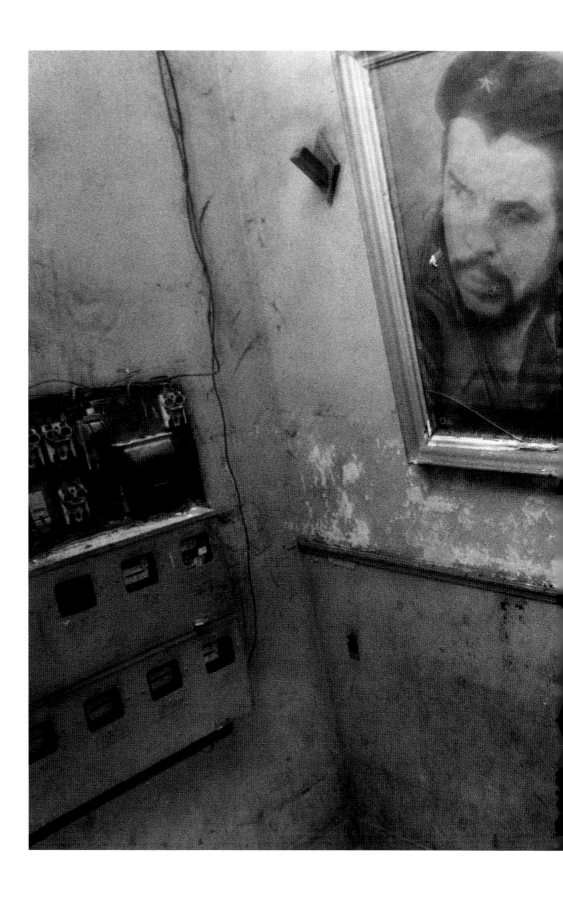

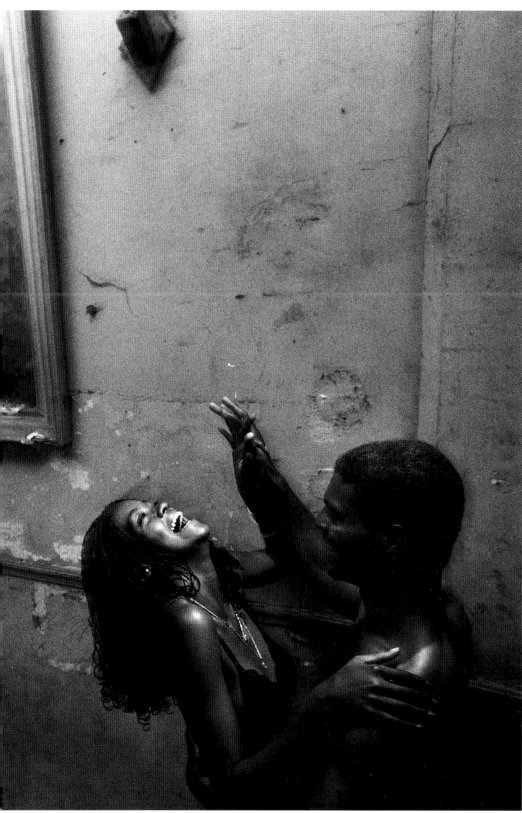

PETER GINTER
Bilderberg,
Germany

**THIRD PRIZE
SINGLES**

9649

9649
Che Guevara, the icon of the Cuban revolu-
tion, looks down on its children. Thirty-six
years on, Che's former comrade in arms Fidel
Castro is struggling with the realities of the
post-communist world. Apparently oblivious
of their country's plight, a young couple
dance the night away in the dilapidated lobby
of what was once a hotel.

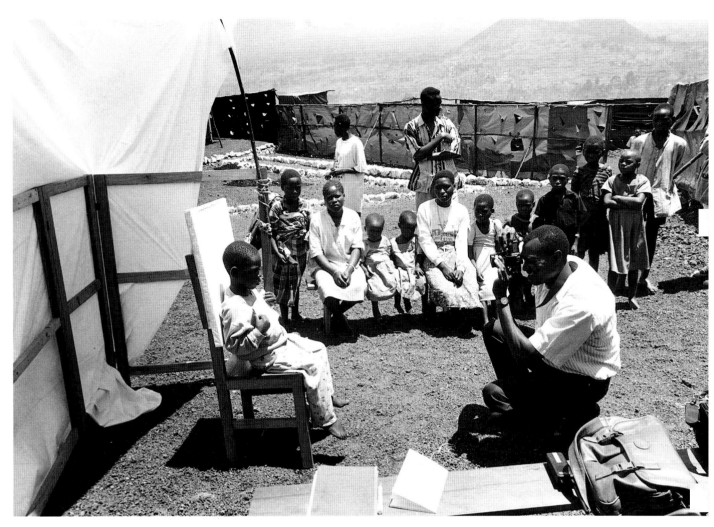

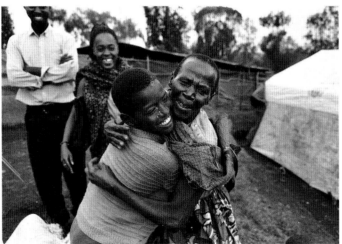

REZA
Iran, Sygma,
France

**HONORABLE
MENTION
STORIES**

9650

9650

In April and July 1994 some one-and-a-half million Rwandans fled their country. In the confusion, 27,000 children were separated from their families. Aid organizations came up with the idea of photographing these 'non-accompanied infants' to facilitate identification. Mobile studios were installed (facing page, top) and exhibitions organized (top). Far left: At Kashusha refugee camp in eastern Zaire, brothers Simon and Paul are happily reunited with their grandmother Seraphine. The other pictures show a center for the reintegration of handicapped victims of the Rwandan civil war in Bukavu and (above left) a psychiatric clinic opened by the Brothers of Charity.

**VLADIMIR
SYOMIN**
Radonezh
Newspaper,
Russia

**SECOND PRIZE
SINGLES**

9651

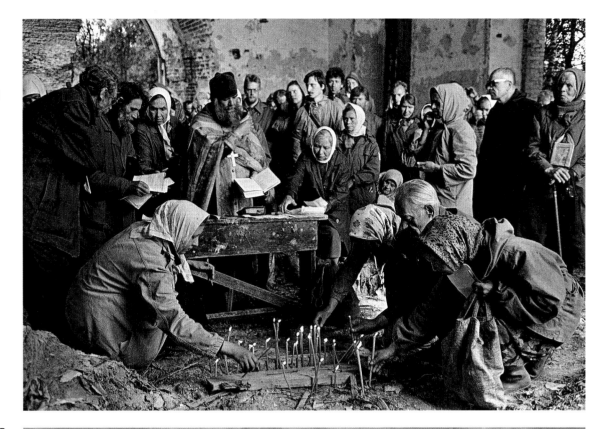

MANUEL BAUER
Lookat Photos
for Du Magazine,
Switzerland

**HONORABLE
MENTION
SINGLES**

9652

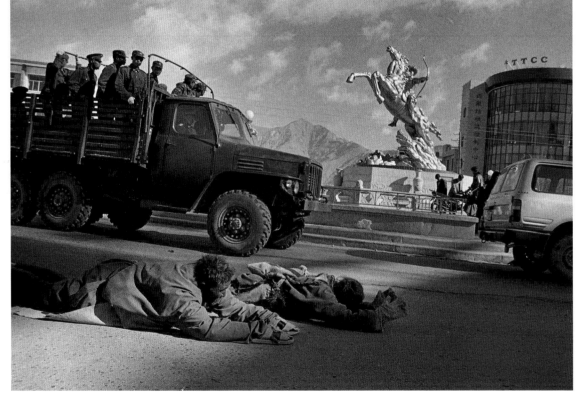

9651
Despite 75 years of official atheism, religious
faith in Russia is as intense as ever. Here a
priest conducts a service as part of an annual
pilgrimage near Velikoretskaya, to the north-
east of Moscow. It takes the pilgrims three
days and nights to reach the hillside where an
icon of St. Nikolai Ugodnik was discovered
in 1383.

9652
In Tibet's Holy City of Lhasa, which was
forbidden territory for western visitors until
1951, three ring roads encircle the inner
chapels of Jokhang Temple, the temple itself
and the old city center. In the outermost road,
the eight-kilometer-long Lingkhor, pilgrims
prostrate themselves as a truck laden with
Chinese soldiers speeds by.

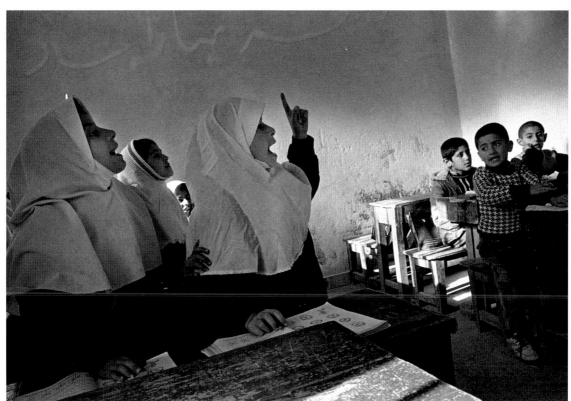

THOMAS KERN
Lookat Photos
for Du Magazine,
Switzerland

FIRST PRIZE
SINGLES

9653

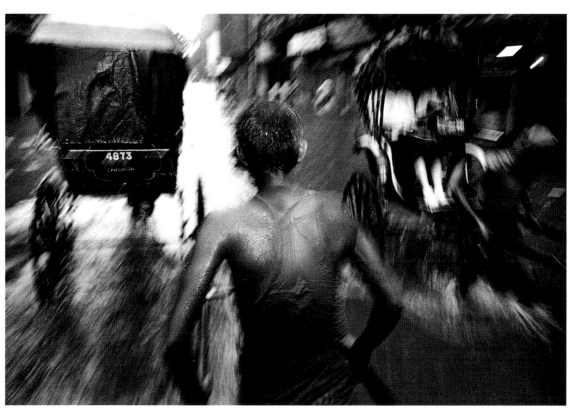

FERNANDO
MOLERES
Spain

9654

9653
A school class in Masoleh, a picturesque vil-
lage perched high above the Caspian Sea on
the edge of Iran's Elburz mountains. Six years
after the death of Ayatollah Khomeini Iran's
closed, fundamentalist society is experienc-
ing a steady exodus of young people to the
city. At this school only 17 pupils and two
teachers remain.

9654
During the monsoon season rickshaws are
the only practical means of transport in the
narrow, flooded streets of Calcutta. Yet most
foreign visitors find it embarrassing to be
conveyed by the physical effort of a human
being. As a result the 'rickshaw-wallahs', who
rent their vehicles by the day, are dependent
on local passengers for their minimal fares.

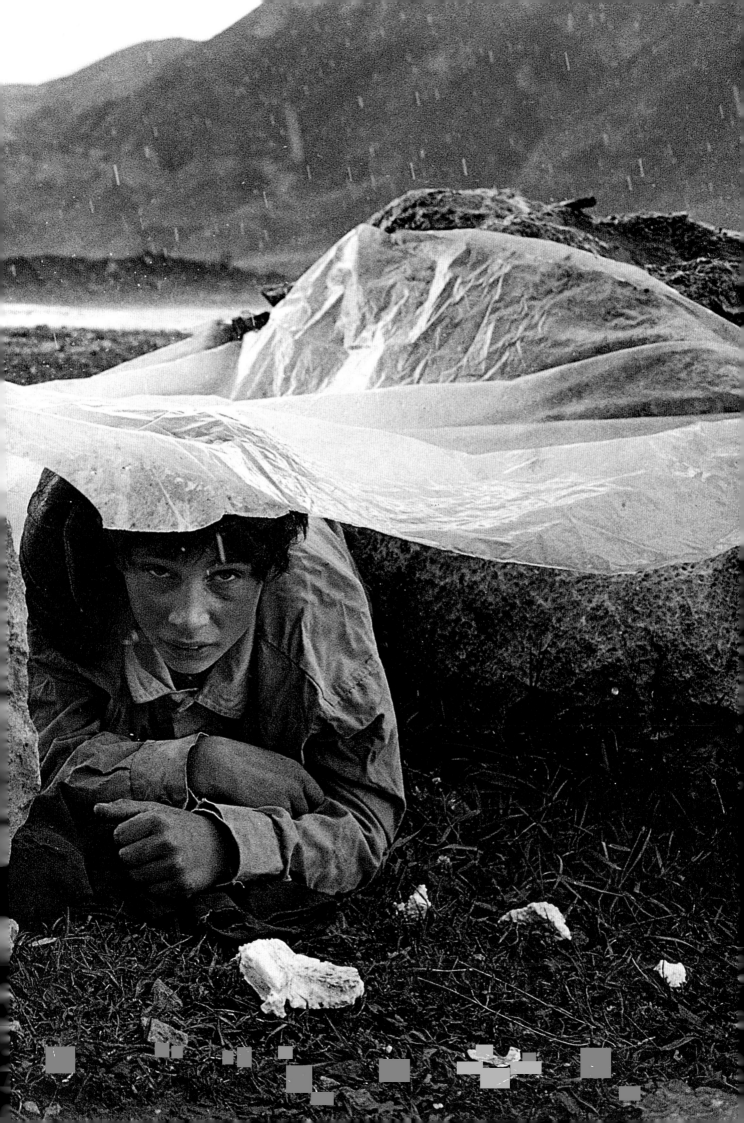

THOMAS KERN
Lookat Photos
for Neue Zürcher
Zeitung Folio,
Switzerland

**THIRD PRIZE
STORIES**

9655

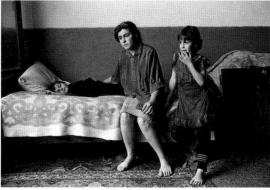

9655 (story starts on p. 108)
Dagestan, a Russian republic on the northern flanks of the Caucasus mountains, rarely makes the news. For three-quarters of the year the people living in this rocky, inhospitable land are dependent on nearby Chechnya for their grain imports. Numbering under two million, they divide into more than 30 ethnic groups, many with their own languages. They are united in their veneration for Shamil, a historic leader from the Czarist era, who stands for self-determination, and in their staunch brand of Sunnite Islam. While some refugees from the civil war in Chechnya have found shelter here (far right), the peoples of Dagestan are content to continue their harsh existence as they have always done.

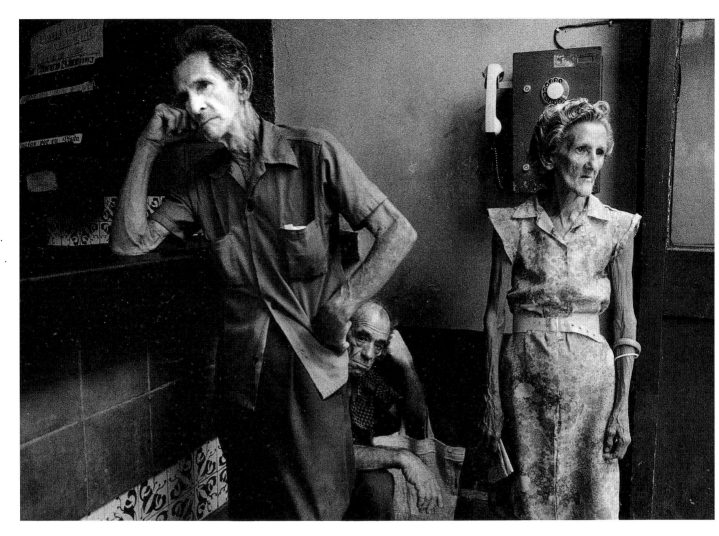

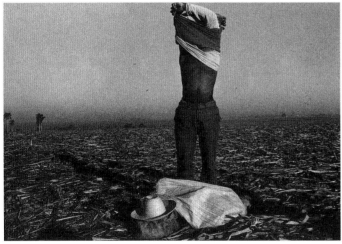
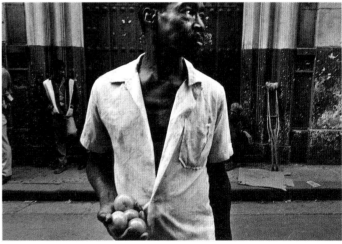

ERNESTO BAZAN
Agenzia Contrasto,
Italy

**FIRST PRIZE
STORIES**

9656

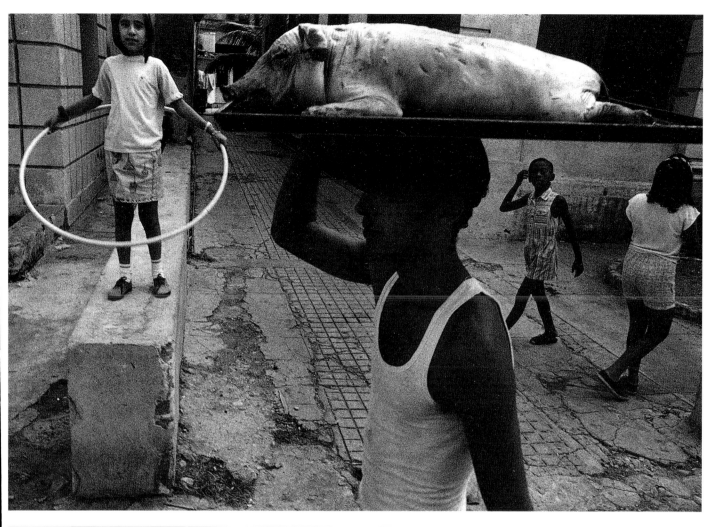

9656

Cuba remains one of the last monuments to Marxism. Fidel Castro, its 69-year-old leader, may occasionally don civilian clothes, but his concessions to capitalism don't compromise the communist creed. The 'special period' Castro proclaimed after the fall of the Soviet Bloc has brought much hardship, but no one has yet come forward to challenge his leadership.

With great resilience and resourcefulness the Cuban people eke out a living cutting sugar cane, selling tomatoes or newspapers (above). Despite all the dearth and discomfort, there is also a time for celebration and partying, for a romantic dance and a roast pork dinner on New Year's Day (top).

113

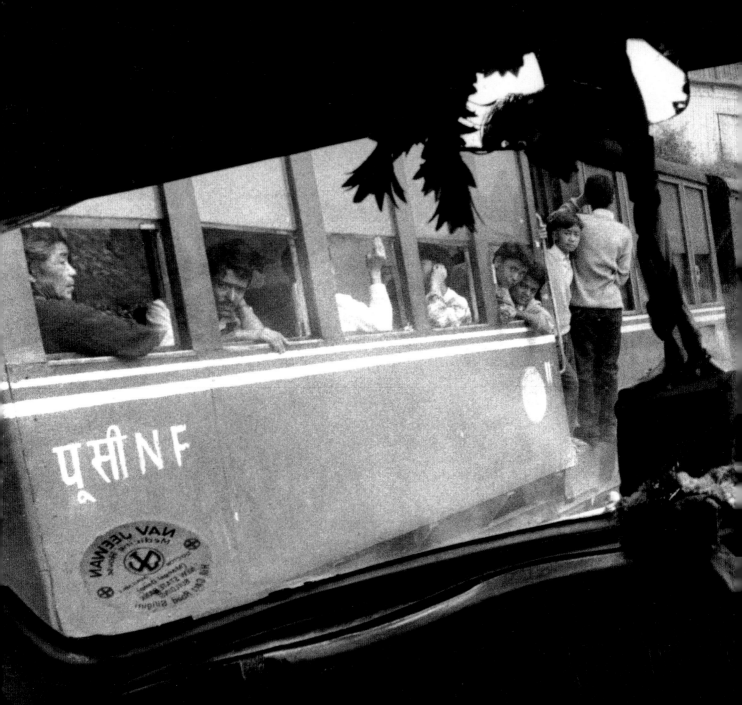

STEPHEN DUPONT
Australia,
Independent
Photographers
Group,
UK

**SECOND PRIZE
STORIES**

9657

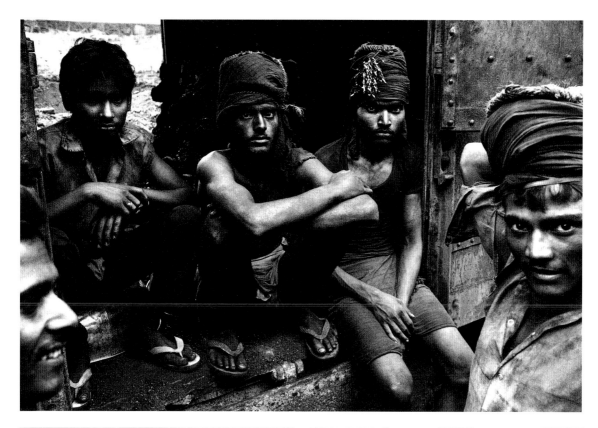

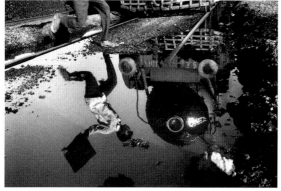

9657 (story starts on p. 114)
The foundations for India's proud claim to having the fourth largest railway system in the world were laid in 1851, when the first steam locomotive started running not far from Delhi. Over the years, about 24,000 followed. Despite the inevitable conversion to electric and diesel traction, some steam engines are still in active service today.

Overleaf: Darjeeling's 'toy train' chugs into the foothills of the Himalayas. Above: Firemen and mechanics work, rest and get changed in loco sheds in Udaipur, Moradabad and Coonoor. Far right: Throughout India, riding the running board is a popular sport. Following pages: At Mavli Junction, children are seen off by the holy animal of Hinduism.

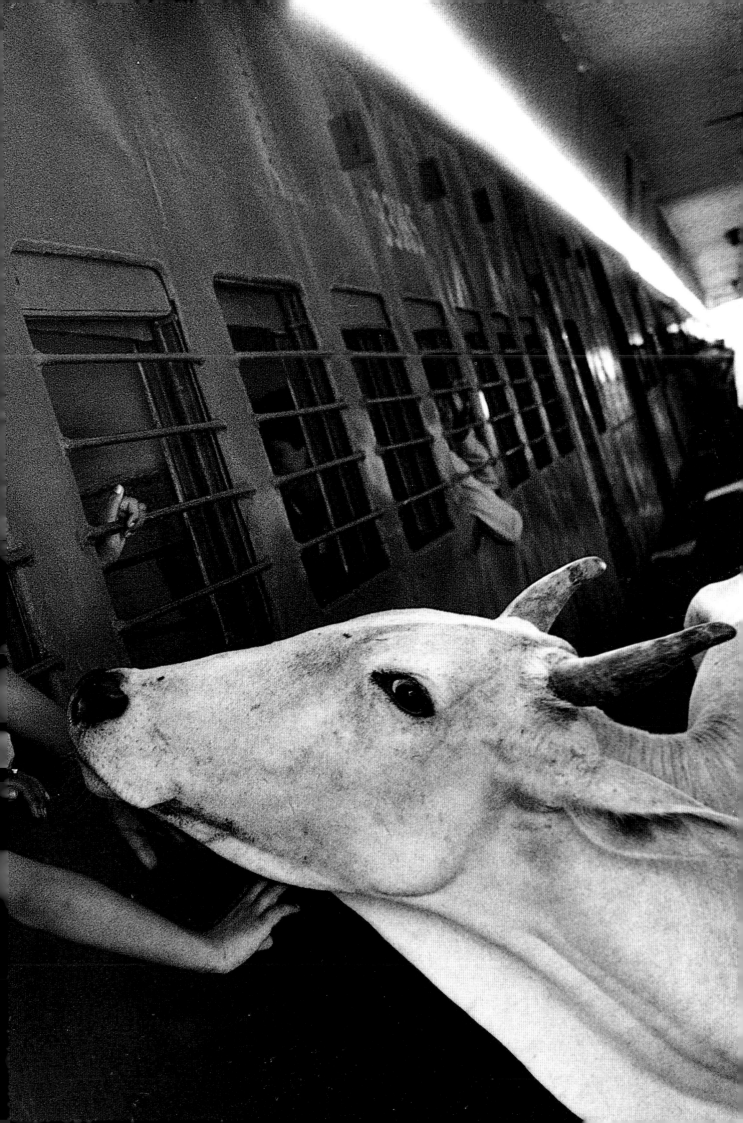

PRIZEWINNERS

WORLD PRESS PHOTO OF THE YEAR 1995

The Premier Award for the World Press Photo of the Year is awarded to the photographer who has been most successful in portraying the essence of an event or a situation. The picture is judged on news value as well as creative perception.

Lucian Perkins · The Washington Post, USA · **6**
'Young Boy on a Bus Heading away from the the War Zone, Chechnya, May'

WORLD PRESS PHOTO CHILDREN'S AWARD

An international jury of schoolchildren select their own favorite picture from about 300 images included in the final rounds of the contest.

David C. Turnley · Detroit Free Press/Black Star for Time Magazine, USA · **66**
'Refugee Woman from Srebrenica'

SPOT NEWS

1 Sholihuddin · Jawa Pos Daily, Indonesia · **10**
'Truck with Sports Supporters Topples over, Surabaya, East Java, 17 May'

2 Carol Guzy · The Washington Post, USA · **18**
'Unclaimed Bodies in City Morgue, Port-au-Prince, Haiti'

3 Jim Argo · Daily Oklahoman/Saba Press Photos, USA · **19**
'Oklahoma City Federal Building Bombing, 19 April'

Honorable Mention
Chris Steele-Perkins · Magnum Photos, UK for Der Spiegel Magazine, Germany · **19**
'Man Lies Beaten in the Street, Johannesburg, December'

Honorable Mention
Anthony Suau · The New York Times Magazine, USA · **18**
'Man Searches for his Sons among Corpses in Mass Grave, Grozny, February'

SPOT NEWS STORIES

1 Patrick Chauvel · France, Sygma for Newsweek Magazine, USA · **12**
'Grozny, January'

2 Paul Lowe · Magnum Photos, UK for Newsweek Magazine, USA · **20**
'Massacre at Kibeho Camp, Rwanda, April'

3 Jon Jones · UK, Sygma, France · **26**
'Wounded Civilians, Grozny, January'

GENERAL NEWS

1 Lucian Perkins · The Washington Post, USA · **6**
'Young Boy on a Bus Heading away from the War Zone, Chechnya, May'

2 Anthony Suau · Time Magazine, USA · **50**
'Grozny after January Bombardments'

3 Jacques Langevin · Sygma, France · **60**
'Jacques Chirac after Victory in the French Presidential Election, Paris, 7 May'

GENERAL NEWS STORIES

1 Anthony Suau · The New York Times Magazine, USA · **52**
'Razborka: Russia's Business and Crime'

2 David C. Turnley · Detroit Free Press/Black Star for Time Magazine, USA · **62**
'Refugees in the Balkans'

3 Eric Bouvet · Le Figaro Magazine, France · **58**
'Russian Special Forces in Chechnya'

Honorable Mention
Fouad Elkoury · Lebanon, Rapho, France · **68**
'Palestinians'

Honorable Mention
André Lambertson · The Baltimore Sun, USA · **70**
'Baltimore Kids and Drugs'

PEOPLE IN THE NEWS

1 Barbara Kinney · The White House, USA · **34**
'Before Signing the Middle East Peace Accord, Washington DC, 28 September'

2 James Nachtwey · Magnum Photos for Time Magazine, USA · **34**
'Chechen Mothers, January'

3 Joe McNally · Life Magazine, USA · **35**
'Portrait of Kim Phuc, the "Napalm Girl", 23 Years Later'

PEOPLE IN THE NEWS STORIES

1 Derek Hudson · UK, Life Magazine, USA, · **36**
'Children of the "Desert Storm" '

2 Stephanie Welsh · Newhouse News Service, USA · **28**
'Female Circumcision Ritual, Kenya'

3 Nadia Benchallal · Contact Press Images, France · **32**
'Bosnian Women and Children from Srebrenica in Refugee Camp, Tuzla, July'

SPORTS

1 Bill Belknap Boston Herald, USA **38**
'Red Sox John Valentin Dives Back to
First Base, Fenway Park, Boston'

2 Keith Bernstein Independent Photographers Group, **42**
UK
'Gymnast Kanukai Jackson During
Training, London'

3 James Stewart Associated Press, USA **43**
'Stan Fox Crashes during the Indy 500'

SPORTS STORIES

1 Francesco Cito Italy, **40**
'Palio of Siena'

2 Stephen Dupont Australia, Independent **48**
Photographers Group, UK
'Turkish Oil Wrestling'

3 Stephan Vanfleteren Belgium, Agence Vu, France **44**
'Young Cuban Boxers'

THE ARTS

1 Li Nan Newsphoto Weekly, **91**
People's Republic of China
'Liaocheng Acrobatics School for
Children, China'

2 Jürgen Gebhardt Stern Magazine, Germany **90**
'Berlin Reichstag by Christo'

3 Stéphane Compoint Sygma, France **91**
'Marine Archaeologists at the Site of
Pharos Lighthouse, Alexandria, Egypt'

THE ARTS STORIES

1 Lori Grinker Contact Press Images for **84**
Natural History Magazine, USA
'Musical Society for the Blind, Cairo'

2 Zeng Nian People's Republic of China, **92**
Contact Press Images, France
'Company of Disabled Acrobats, China'

3 Nancy Ellison Sygma for Life Magazine/ **88**
American Ballet Theatre, USA
'Dancers of the American Ballet Theatre'

SCIENCE AND TECHNOLOGY

1 Louie Psihoyos Matrix for National **94**
Geographic Magazine, USA
'Five Hundred Channel Television
System, Los Angeles'

SCIENCE AND TECHNOLOGY STORIES

1 Patrick Landmann Arenok Presse for Geo Magazine, **98**
France
'Scale Model Experiments, France'

2 Manfred Linke Laif Photos & Reportagen, Germany **96**
'Dubai Camel Hospital'

3 Patrick Landmann Arenok Presse for Geo Magazine, **100**
France
'Mummy of San Lazzaro, Venice'

NATURE AND THE ENVIRONMENT

1 Olivier Blaise France **72**
'Swimming Elephant, Bay of Bengal'

2 Jeff Vinnick Reuters News Pictures, Canada **77**
'Birth of a Baby Beluga, Vancouver
Aquarium'

3 Bryan Patrick The Sacramento Bee, USA **77**
'Nyala Antelope Gives Birth at
Sacramento Zoo'

NATURE AND THE ENVIRONMENT STORIES

1 Michael Nichols National Geographic Magazine, USA **78**
'Wildlife in Ndoki, Central Africa'

2 Gideon Mendel South Africa, Network Photographers, **74**
UK for Greenpeace Magazine, Germany
'Senegalese Fishing Community'

3 Dod Miller Network Photographers, UK **82**
'London Smokers'

DAILY LIFE

1 Thomas Kern Lookat Photos for Du Magazine, **107**
Switzerland
'Primary School at Masoleh, Iran'

2 Vladimir Syomin Radonezh Newspaper, Russia **106**
'Russian Pilgrims'

3 Peter Ginter Bilderberg, Germany **102**
'Cuban Dance'

Honorable Mention
Manuel Bauer Lookat Photos for Du Magazine, **106**
Switzerland
'Tibetan Pilgrims, Lhasa'

DAILY LIFE STORIES

1 Ernesto Bazan Agenzia Contrasto, Italy **112**
'Cubans'

2 Stephen Dupont Australia, Independent Photographers **114**
Group, UK
'India's Last Steam Trains'

3 Thomas Kern Lookat Photos for Neue Zürcher **108**
Zeitung Folio, Zwitzerland
'Dagestan'

Honorable Mention
Reza Iran, Sygma, France **104**
'Displaced Children of Rwanda'

CONTEST 1996

In 1996, 3,068 photographers from 103 countries submitted 29,116 entries. The participants are listed according to nationality as stated on the contest entry form. In unclear cases the names are listed under the country of mailing address.

ALBANIA
Besim Fusha
Naim Kasapi
Zamir Marika
Kostandin Poga
Llesh Prendi

ALGERIA
Louiza Ammi
Nour-Eddine Bechar
F. Zohra Bensemra
Ouahiba Kichou

ARGENTINA
Martin C.E. Acosta
Aldo Juan Alessandrini
Jorge Luis Aloy
Mariana Araujo
Alejandro Balaguer
Mauricio Bustamante
Ruben Adrian Cabot
Guillermo Canton
Mario Cocchi
Viviana Ines D'Amelia
Gerardo Martin Dell'Orto
Raul Di Giano
Diego F. Díaz
Alberto Alejandro Elizs
Benito F. Espindola
Horacio Mario Fernandez
M. Cristina Fraire
Alejandro Garcia
Gustavo Gilabert
Julio Giustozzi
Alejandro Miguel Gómez
Maria Elena Hechen
Claudio Herdener
Alfredo J.L. Herms
Maria Angelica Kusmuk
Augusto Larrea
Eduardo Victor Longoni
Enrique Pedro Marcarian
Hugo Oscar Meligeni
Miguel Angel Mendez
Luis Alberto Micou
Diana Musacchio
Horacio Paone
Guillermo Adrian Pardo
Daniel Horacio Pessah
Christopher Pillitz
Santiago Porter
Andres Requena
Pablo Rodriguez Torres
Sergio Ruiz
Laura Elena Salinas
Juan Jesús Sandoval
Ricardo Sanguinetti
Martin Horacio Saucedo
Nestor Roberto Sieira
Mariano Federico Solier
Rubén J. Sotera
Osvaldo Ricardo Stigliano
Gustavo Marcelo Suarez
Mauricio Tokman Berszader
Leo Vaca
Antonio Valdez
Lucía Vassallo
Carlos Alberto Ventura
Guillermo Viana
Enrique von Wartenberg
Rafael Hugo Yohai

ARMENIA
Rouben Mangasarian
Vyacheslav Sarkisian

AUSTRALIA
Simon Alekna
David Anderson
Tony Ashby
Robert Billington
Ross Bird
Philip Blenkinsop
Mario Joseph Borg
London F. Bus
Steve Christo
Warren Clarke

Tim Clayton
Ron Nelson D'Raine
Anthony Davis
Stephen Dupont
Nicole Emanuel
Brendan Esposito
John Gass
Craig Steven Golding
Steve Gosch
David Gray
Wim Grootenboer
John Hart
Peter Hasson
Phil Hillyard
Glenn Hunt
Martin Jacka
Quentin Cameron Jones
Guy Little
Darryn Lyons
Dean Martin
Fiona McDougall
Darren McNamara
Leon Mead
Andrew Meares
Palani Mohan
Nicholas Moir
Jaime Murcia
Christine Osborne
Trent Parke
Jack Picone
Jeremy Piper
Adam William Pretty
Peter Rae
Jason Reed
Russell Shakespeare
Matthew Sleeth
Peter Solness
Andrew Stark
Tasso Taraboulsi
Andrew Taylor
Ray Titus
Matt Turner
Grant Turner
Donald Turvey
John Veage
Margaret Waller
Madeleine Waller
Rob Young
Reimund Zunde

AUSTRIA
Heimo Aga
Toni Anzenberger
Michael Appelt
Wilhelm Blecha
Peter Granser
Stefan Haring
Manfred Horvath
Helmut Klein
Lois Lammerhuber
Ernst Mayerhofer
Dieter Mayr-Hassler
Veronika Oberhammer
Helmut Ploberger
Reiner Riedler
Reiner Riedler
Chris Sattlberger
Norbert Schmeisser
Kelly Schoebitz
Walter Schweinöster
Alfred Seiland
Matthias Wölfle

BAHAMAS
Andrew Bryan

BANGLADESH
Abir Abdullah
Masud Ahmed
Pavel Akbor
Moinul Alam
Shahidul Alam
Mir Mahboob Rishad Ashraf
Abdul Malek Babul
Md. Yasin Babul
Suvash Kumer Barman
Tapas Barua
Akter Bayazid
Jamal Uddin Chowdhury
Mohidul MD Haque
Proshanta Karmakar Buddha
Nazrul Islam Khan Md.
Abdul Hamid Kotwal
Chanchal Mahmood
Khalil Mahmood Mithu
Tarif Rahman
Tapash Saha
Mukti Salma Rahman
Abdus Shaheed
Shahid Sikdar
Mir Mohiuddin Sohan

Hashi Talukder
Kazi Borhan Uddin
Md. Zia Zahir
Md. Ali Zonaed

BELARUS
Anatoli Kleshchuk

BELGIUM
Philippe de Barsy
Lelen Bourgoignie
Robert van den Brugge
Filip Claus
Guido Coolens
Johan van Cutsem
Luc Daelemans
Sophie Deneumostier
Marc Deville
Karl Donvil
Stephane Fefer
Peter Janssens
Alain Kazinierakis
Carl de Keyzer
Alex Kouprianoff
Olivier Matthys
Koen Meyers
Jean-Pierre Monhonval
Luc Struyf
Nuriel Thies
Hendrik Timmerman
Katinka Vanderbauwhede
Stephan Vanfleteren
Willy Vrancken

BOLIVIA
Simon Armado Duran Vasquez
Hugo Jose Suarez
Rafael Ruben Tejada Tufiño

BOSNIA-HERZEGOVINA
Nihad-Nino Pusija

BRAZIL
Norma Albano Alves
Ormuzd Alves
Euler Paixao Alves Peixoto
Paulo Amorim
Welton Araujo
Paulo Araújo
Leonardo Aversa
Izabel Baldoni
Nário Barbosa
Ruy Baron Junior
Carlos Alberto Vilas Boas
Luiz Jose Borges Neto
Mario Henrique Brasil
Monique de Barros Cabral
Jorge Luiz Cardosao
Alexandre Cassiano de Sousa
Ivaldo Cavalcante Alves
Julio Cesar Cavalheiro
Adrovando Claro de Oliveira
Tina Coelho
Custódio J.B. Coimbra
Jose Luis da Conceicao
Julio Cesar Bello Cordeiro
Leonardo Dias Correa
Marcos Alves da Cruz Lima
Antonio da Cunha Nogueira
José Cláudio Davies da Silva
Cristiane R. Ribas Dávila
Glaucio Dettmar
Ivan Ribeiro Dias
Reynaldo Dias
Marco Dierchxs
José Egberto da Silva
Davi Fernandes da Silva
Michel Abrahao Filho
Ulysses Fernandes de Freitas
Valdir Gomes Friolin
Renan Gepeda
Ari C. Gomes
Masao Goto Filho
Yone Guedes da Costa
Francisco Guedes de Lima
Jorge Guimaraes Hutter
Genaro Antonio Joner
João Carlos Lacerda
Oswald Lee P. Jr.
Ulisses Job Lima
Marco André Lima
Jorge Lopes
Paulo Cesar Lopes Alvadia
Moacyz Lopes Jr
Edison Machado
Benito Maddalena
Clenardo Marinho
Claudio Marques
Manoel Marques Neto
William Soares Maura
Mathilde Molla

Pedro de Moraes
Josenilson Morai
Erivam Morais de Oliveira
Carlos Alves Moura
Marta Nascimento
Luiz Fernando Neves da Silva
Jorge Luiz Serra Nicolella
Ricardo Nilton
Cleide Maria de Oliveira
Ricardo Barreiros Oliveira
Ronaldo de Oliveira
Marcelo de Olivera Fonseco
Fernando José H.B. Pereira
Julio Pereira
Eraldo Peres da Silva
Paulo Martins Pinto
Marcos André Pinto
Fabrio Carles Pozzebom
Marcos Prado
Joao Quaresma
Carolina Quintanilha Ribeiro
Marcio Resende
Silvio Ricardo Ribeiro
José Ribeiro de Oliveira
Bernardo F.G.J.M. Ridolfi
Everaldo Rocha
Evelson Rodriguez de Freitas
Christina Rufatto
Sebastiao Salgado
Epitácio P.F.T. dos Santos
Roberto Scola
Alex Silva
Carlos Alberto da Silva
Severino Antionio da Silva
Silvio de Silva
Claudio Luiz Silva da Silva
Sandra Silva de Souza
Fernando Souza
Agliberto C. Lima Souza
Marcos de Souza Mendes
Rodney Suguita
Pedro Sutter
Márcio Teixeira
Marco Antonio Flores Teixeira
Ricardo Teles
Alexandre Tokitaka
Raimundo Soares Valentim
Djalma de Aguiar Vassão
Luiz Armando Vaz
Ariovaldo Vicentini
José Tupinambá Vidal
Ovidio Vieira
Ed Viggiani
Marcelo Vigneron
Luciana Whitaker

BULGARIA
Milan Christev
Zafer Galibov
Martin Georgiev
Ivan Iochev
Lyubomir Jelyaskov
Jordan Jordanov
Vassil Karkelanov
Momchil Mihailov
Vesel Nikolaev Veselinov
Peter Petrof

BURKINA
Guira Bare
Etienne Kafando
Aristide Ouedraogo

CANADA
Ronald Adam
Roy H. Andersen
Brent Anderson
Cindy Andrew
Bernd Beisinger
Tony Bock
Bernard Brault
Geraldine Brophy
Shaughn Butts
Frédéric Chartrand
David Chidley
Timothy Clarke
A. Clive Cohen
Jerome Conquy
Barbara Davidson
Shane Doyle
Richard Emblin
Edward Gajdel
Carolle Gallienne
Richard Gilmore
Nicolas Girard
Roxanne Gregory
Jacques Grenier
Chris Helgren
Gary Hershorn
Pedro Isztin
Judith Kostilek

Jean Lauzon
Ronald D. Lee
Richard Lee
Roger Lemoyne
Rick Madonik
Chris Malette
Allen McInnis
Jeff McIntosh
Bryan McLellan
Jim Merrithew
Russell Monk
Gary Moore
Robert Mooy
Julie Oliver
Paul van Peenen
Tom Pidgeon
Joshua Radu
Milosz Rowicki
Dario Ruberto
Steven Russell
Rick Rycroft
Robert Semeniuk
Peter Sibbald
Steve Simon
Boris Spremo
Larry Towell
Liz Van'Terve
Andrew Vaughan
Jeff Vinnick
Andrew Wallace
George Webber
Larry Wong
Andrew Yeung

CHILE
Stella Alvear Klett
Juanita Andrea Ayala Gac
Sergio Yanik Cartes Núñez
Javier Enrique Godoy Fajardo
Waldo Nilo
Catherine Ilenia Ramirez López
Carlos Reyes-Manzo
Ricardo Rafael Rojas Nuñez

CHINA
Bei Jianguo
Cao Ning
Cao Wei Song
'Steven' Peng Chen
Chen Junchang
Chen Qiang
Chen Yanzhong
Cheng Gui Min
Cheng Heping
Chenggong Zheng
Chenke Jingye
Cui Bo Qian
Cui Zhi Shuang
Cun Yun Zhou
Deng Ruyi
Dong Lishi
Donghong Chao
Fan Ren Li
Fu Chun Wang
Gong Jian-Hua
Gong Xiao Song
Gou Yu Sheng
Guo Bailin
Guo Jianshe
Guo Yi Jiang
Hai Bo Yu
Han Qian
Han Shi Qi
Han Yunmin
He Jiao
Hongjie Ma
Hu Weimin
Wen Huang
Huang Jingda
Huang Qingjun
Huibin Lu
Ji Ping Lang
Jia Guo-rong
Jian Guo
Jiang Dong
Jing Si Liu
Ju Guangcai
Simon Kwong
Lan Hongguang
Li Cheng
Li Gang
Li Huatang
Li Hui
Li Ming
Li Nan
Li Shaowu
Li Siqiang
Li Tai Hang
Li Xiaoguo
Li Xiuyang
Li Xudong

Liang Daming
Liang Xianjin
Lin Shaozhong
Liu Guo Qiang
Liu Jiemin
Liu Kai Xuan
Liu Liqun
Liu Wei
Liu Weiqiang
Liu Yadong
Long Xiang
Lu Guang
Lu Qi Hai
Man Zhili
Mao Ching Hua
Mao Shuo
Miao Fengwu
Ming Zhong
Peng Hao
Peng Nian
Qi Shangmin
Qian Houqi
Qijie Shuang
Qin Datang
Qing Jing Song
Qu Zhao Ping
Ren Xihai
Shao Hua
Shen Biaodong
Shi Xizhou
Song Ziming
Sun Yu Hiu
Tao Wen Xiang
Teng Ke
Tian Fei
Claude Tsang Ka-Kit
Wan Xinke
Wang Huaigui
Wang Li Qiang
Wang Riling
Wang Wenlan
Wang Xinyi
Wei Hai-Zhou
Weimin Wang
Wong Ming Zong
Wu Feng Sheng
Wu Haibo
Wu Jialin
Wu Shuijin
Wu Xue-hua
Wu Yaolin
Wu Zhiyi
Xia Li
Xia Yan
Xiao Long Wang
Xiaoyun Luo
Xie Minggang
Xie Qi
Xu Guo Kai
Xu Jianrong
Xu Jingxing
Xu Ruixin
Yan Bailiang
Yang Fu Sheng
Yang Donghui
Yang Hai Peng
Yang Jian
Yang Shizhong
Yang Tao
Yang Xinyu
Yao Zhi Gang
Yu Hui Tong
Yuan Dongping
James Zeng Huang
Zeng Nian
Zha Chun Ming
Zhang Cheng
Zhang Hong Quan
Zhang Jian Lin
Zhang Jingyun
Zhang Jusheng
Zhang Nan Xiu
Zhang Si-en
Zhang Wei
Zhang Xiaoyu
Zhang Xinmin
Zhang Yan
Zhang Yanhui
Zhang Yi
Zhang Yiwen
Zhang Yulin
Zhao Ke
Zhao Xiu Ying
Zhao Ya Shen
Zheng Yongqi
Zhi Jian
Zhonglu Fan
Zhou Guoqiang
Zhou Hong Ming
Zhou Qing Xian
Zhou Xiao-Hui

Zhou Yanming
Zhou Zi Dong
Zhu Xang
Zou Shao-Xin

COLOMBIA
Luis Henry Agudelo Cano
Aldo Brando Léon
Felipe Andres Caicedo Chacon
Abel Cardenas Ortegon
Gerardo Chaves Alonso
Claudia Daut
Jaime Alberto Garcia Rios
José Miguel Gomez Mogollon
Carlos Alonso Linares Pinzon
Bernardo Alberto Peña Olaya
Jairo Alberto Sanchez Nieto
José Sánchez Puentes
Leonardo Vastro Cabra

COSTA RICA
Eduardo López Lizano
Manuel Enrique Vega Quesada

CROATIA
Darko Bandic
Antonio Bat
Dubravko Darabus
Tom Dubravcc
Kresimin Duric
Marko Gracin
Fjodor Klaric
Vlado Kos
Sasa Kralj
Zvonimir Krstulovic
Josip Miso Lisanin
Josip Petric
Jakov Prkic
Nikola Solic
Nikola Tacevski
Bozidar Vukicevic

CUBA
José Azel
Héctor Fernández Ferrer
Jorge Lopez Viera
Ernesto Monzón Montes
Liborio Noval Barberá
Ahmed Velazquez Sagues

CYPRUS
Andreas Vassiliou

CZECH REPUBLIC
Pavel Dias
Ladislav Hartman
Lenka Hatasová
Vaclav Hubata-Vacek
Antonin Kratochvil
Michal Krumphanzl
Jaroslav Kucera
Dana Kyndrova
Tomki Nemec
Lukás Procházka
Roman Sejkot
Jan Sibik
Josef Sloup
Pavel Stecha
Jaroslav Tatek
Zdenek Thoma
Jan Trestik
Petr Vilgus
Stanislav Zbynek
Igor Zehl
Adolf Zika

DENMARK
Kim Agersten
Soren Bidstrup
Mads Black Ifversen
Jan Dago
Jesper Dall
Francis Joseph Dean
Jacob Ehrbahn
Finn Frandsen
Klaus Gottfredsen
Jan Anders Grarup
Tine Harden
Nicolai Howalt
Carsten Ingemann
Michael Jensen
Jan Eric Johnsen
Joachim Ladefoged
Claus Bjorn Larsen
Soren Lauridsen
Hanne Loop
Soren Lorenzen
Nils Meilvang
Voja Miladinovic
Kim Rasmussen
Niels Reiter

Lars Ronbog
Henrik Saxgren
Preben B. Soborg
Thomas Sondergaard
Jorn Stjerneklar
Torben Stroyer
Ernst Tobisch
Anne Mette Welling
Robert Wengler

ECUADOR
Diego F. Granja Estrella
Cesar Joaquin Guaña Cando
Alfredo Ernesto Lagla Lagla

EGYPT
Ahmed M. Khalil Al-Khatib
Ezzat Mohamed El Semary
Sayed Ahmed Gomaa
Magdy Ibrahim Hana
Hassan Aly Hassan
Wessam Mahanna
Ahmed Youssef Mohmed

ERITREA
Woldeyohanes Hadgu
Russom Fesahaye
Seyoum Ghebremariam
Tcsfaldct Kidanc
Kidane Tekali
Sebhatu Kifle
Gebremedhin Tsega Mehari
Seyoum Tsehaie

ESTONIA
Harri Rospu
René Velli
Viktor Vesterinen

FINLAND
Aimo Hyvärinen
Markus Jokela
Soile Kallio
Ensio Kauppila
Pentti Koskinen
Matti J. Leinonen
Laura Luostarinen
Matti Matikainen
Timo Palm
Juha Pitkänen
Timo Pylvänäinen
Erkki Raskinen
Kirsi Reinikka
Kimmo Räisänen

FRANCE
Pierre Abensur
Antoine Agoudjian
Vincent Amalvy
Maher Attar
Dominique Aubert
Patrick Aventurier
Georges Bartoli
Pascal Baudry
Eric Bauer
Remi Benali
Nadia Benchallal
Georges Bendrihem
Virgile Bertrand
Alain Bétry
Bernard Bisson
Alain Bizos
Olivier Blaise
Christian Boisseaux-Chical
Reynald Boivin
Guillaume Bonn
Denis Boulanger
Alexandra Boulat
Bruno Bourel
Stéphane Bourgeois
Eric Bouvet
Dominique Bravermann
Jérôme Brézillon
Christophe Calais
Jean François Campos
Frederic Carol
Jean-François Castell
Philippe Chancel
Jean-Marc Charles
Julien Chatelin
Patrick Chauvel
Roger Claudin
Stéphane Compoint
Bruno Couderc
Olivier Coulange
Jean-Louis Courtinat
François Darmigny
Georges Dayan
Frédéric Debilly
Gautier Deblonde
Luc Delahaye

Jerome Delay
Jacques Demarthon
Michel Denis-Huot
Xavier Desmier
Gérard Diez
Emmanuel Dunand
Guy Durand
Sophie Elbaz
Patricio Estay
Albert Facelly
Franck Faugère
Laurence Fleury
Brice Fleutiaux
Patrick Forestier
Frank Fournier
Frédéric Fournier
Marc Francotte
Raphaël Gaillarde
Cedric Galbe
Yves Gellie
Norbert Genetiaux
Frédéric Girou
Daniel Giry
Pierre Gleizes
Georges Gobet
Jacques Graf
Olivier Grunewald
Michel Gunther
Pascal Guyot
Valéry Hache
Bruno Hadjih
Philippe Hays
Catherine Henriette
Guillaume Herbaut
Mat Jacob
Patrick James
Olivier Jobard
Armineh Johannes
Gérard Julien
Ladislas Kadyszweski
Patrick Landmann
Jacques Langevin
Cyril Le Tourneur d'Ison
Didier Lefevre
Vincent Leloup
Christophe Lepetit
Catherine Leroy
Philippe Lissac
Philippe Lopparelli
Laurence Louis
Marc Lucas
Eric Mangeat
Richard Manin
Jérôme Martin
Christian Maury
Patrick Mesner
Philippe Millereau
Gilles Mingasson
Luc Moleux
Bruno Morandi
Eve Morcrette
Gerard Noël
Alain Noguès
Pascal Pavani
Gerard Planchenault
Emmanuelle Purdon
Dominique Quet
Noël Quidu
Benoît Rajau
Patrick Robert
Joël Robine
Mathieu Rousseaux
Jean-Philippe Rozé
Erik Sampers
Lise Sarfati
Frédéric Savariau
Laurent Sazy
Roland Seitre
Serge Sibert
Jean-Noël de Soye
Daniel Staquet
Laurent van der Stockt
Goran Tacevski
Laurent Theillet
Daniel Thierry
Jean-Pierre Thomas
Ilhami Uncuoglu
Pierre de Vallombreuse
Gerard Vandystadt
Michel Viard
Luc Wouters
Jean-Marc Zaorski

GEORGIA
Shakhvalad Aivazov
Irakliy Chokhonelidze
Michacl Japaridzc

GERMANY
Michael Anacker
David Ausserhofer

Henning Bangen
Patrick Barth
Wilfried Bauer
Hartmut Beifuss
Wolfgang Bellwinkel
Fabrizio Bensch
Claus Bergmann
Sörli Binder
Daniel Biskup
Frieder Blickle
Christoph Boeckheler
Lutz Bongarts
Karsten Bootmann
Wolfgang Alexander Borm
Wolf Böwig
Hubert Brand
Marcus Brandt
Kerstin Braun
Ulrich Brinkhoff
Christian Brinkmann
Hansjürgen Britsch
Reinhard Willi Bruckner
Frank Bründel
Hans-Jürgen Burkard
Ulrich Dahl
Heinz Dargelis
Uli Degwert
Markus Dlouhy
Thomas Dorn
Thomas Dworzak
Hans Richard Edinger
Werner Eifried
Stephan Elleringmann
Norbert Enker
Martin Ernst
Thomas Ernsting
Markus Essler
Stefan Falke
Ina Fassbender
Rüdiger Fessel
Michael Fink
Sven Fischer
Jörg Axel Fischer
Guido Frebel
Peter Frischmuth
Sascha Fromm
Ronald Frommann
Jürgen Fromme
Jan Gallas
Jürgen Gebhardt
Thomas Geiger
Markus Gilliar
Peter Ginter
José Giribás
Bodo Goeke
Andreas H.G. Goetze
Josef Pego Gottwald
Holger Gross
Kirsten Haarmann
Kerstin Hacker
Roland Haderlein
Oliver Hamann
Kerstin Hamburg
Gerald Hänel
Martin Hangen
Alfred Harder
Heinrich K.-M. Hecht
Volkmar Heinz
Günter Held
Wim van der Helm
Andreas Herzau
Markus C. Hildebrand
Marcus Darryl Hirthe
Jan Hollants
Milan Horacek
Dietmar Horn
Andrea C. Hoyer
Philipp Hympendahl
Ralf Ibing
Christian Jungeblodt
Wolfgang Aaron Kaszubiak
Marcus Kaufhold
Reinhard Kemmether
Falk Kienas
Richard Kienberger
Lorenz Kienzle
David Klammer
Herbert Knosowski
Hans-Jürgen Koch
Heidi Koch
Axel Koster
Uwe Kraft
Rainer Kraus
Guido Krawczyk
Brigitte Krenn
Ines Krueger
Rcinhard Kuhn
Peter Kullmann
Wolfgang Kumm
Michael Kunkel
Bernhard Kunz

Wolfgang Kunz
Michael Kupferschmidt
Hans Kwiotek
Martin Langer
Paul Langrock
Connie Lehmann
Eva Leitolf
Jens Liebchen
Stefan Lied
Ralf Lienert
Manfred Linke
Andreas Lobe
Bernd Löber
Michael Lutz
André Lützen
Björn Lux
Nicole Mai
Birgit-Cathrin Maier
Mathias Marx
Lutz Masanetz
Markus Matzel
Fabian Matzerath
Cornelius Meffert
Martin M. Meir
Rudi Meisel
Peter Meissner
Achim Melde
Karl-Heinz Melters
Dagmar Mcndcl
Guenther Menn
Dieter Menne
Kerstin Merkel
Jens Meyer
Claus Christian Meyer
Thomas Morgenroth
Stephan Morgenstern
Peter Mueller
Sascha Müller
Horst Nebe
Anna Neumann
Gertrud Neumann-Denzau
Rolf Nobel
Thomas Nühnen
Dominik Obertreis
Reimar Ott
Ingo Otto
Günter Passage
Laci Perenyi
Thomas Pflaum
Stefan Pompetzki
Stefan Puchner
Frank Pusch
Christoph Püschner
Martin Pyplatz
Karl-Heinz Raach
Rainer Raeder
Thilo Rückeis
Werner Rudhart
Norbert Rzepka
Joern Sackermann
Stephan Sagurna
Gerard Saitner
Mark Sandten
Sabine Sauer
Claudia Scheen-Eichler
Detlev Schilke
Amos Ulrich Schliack
Judith Schlüter
Bastienne Schmidt
Harald C. Schmitt
Werner Schmitt
Harald Schrader
Markus Schreiber
Michael Schröder
Frank Schultze
Hinrich Schultze
Friedhelm Schulz
Tilman Schuppius
Stephan Schütze
Hartmut Schwarzbach
Daniel Schwarzstein
Klaus P. Siebahn
Patricia Sigerist
Michael Sohn
Bertram Solcher
Sven Sonntag
René Spalek
Achim Sperber
Sabine Spitzl
Wolfgang Staiger
Wolfgang Steche
Wolfgang Steinruck
Thomas Stephan
Andreas Teichmann
Peter Thomann
Edda Treuberg
Zlatko Tulic
Guenay Ulutuncok
Tristan Vankann
Sabine Vielmo
Wolfgang Volz

Helmuth Vossgraff
Frank Wache
Martin Wagner
Stefan Warter
Marcus Werres
Frank Westphal
Philipp Wiegandt
Jens Wilkening
Lutz Winkler
Manfred Wirtz
Knut Zeisel
Wolfgang Zeyen
Reto Zimpel
Andreas Zobe
Samuel Zuder

GHANA
Skido Achulo
Daniel Lanquaye Ordariey

GREECE
Michael Ainalis
Yannis Behrakis
Frangiskos Bizas
Mihalis Boliakis
Iakovos Chatzistavpou
Theodosis Giannakidis
Yannis Goutis
Nikos Halkiopoulos
Yannis Kabouris
John Kanelopoulos
George Karachalis
John Kolessidis
Athanasios Kontogiannis
Theodoros Papadopoulos
Paris Petrides
Lefteris Pitarakis
Fani Sarri
Afroditi Spadidea
Stelios Tsagris
Spyros Tsakiris
Leonidas Tzekas
Alexis Michael Vassilopoulos
Grigoris Vlassas

GUATEMALA
Luis Garcia
Ricardo Szejner Orczyk

HAITI
Carl Juste
Marc Yves Regis

HONG KONG
Chi Kwan Jeffrey Pang

HUNGARY
Eva Arnold
Zoltán Asztalos
Attila Balázs
László Balogh
András Bánkuti
Imre Benkö
Balázs Czagány
László Czika
Istvan Farkas
Zsolt Fekete
Péter Flanek
Imre Földi
Csaba Forrásy
Péter Gyurkó
András Hajdu
Mónika Hévizi
Ferenc Kálmándy
Attila Kisbenedek
Sándor László
Tamás Mike
Zsolt Pataky
Suzanne Petö
Tamás Révész
Zsuzsa Schiller
Csilla Simon
Lajos Soós
Sándor H. Szabó
Péter Szalmás
Zsolt Szigetváry
Illyés Tibor
Tamás Urbán
László Varga
László Végh
Péter Zádor

ICELAND
Hrönn Axelsdóttir
Ragnar Axelsson
Einar Falur Ingólfsson
Kristina Ingvarsson
Bragi Josefsson
Arni Saeberg
Torkell Torkelsson
Sverrir Vilhelmsson

INDIA
Sudi Acharya
Sunil Adesara
Tarapada Banerjee
Asok Banerjee
Vikas Bansal
Shyamal Basu
Rajib Basu
Sandesh Bhandare
Dharmesh S. Bhavsar
Dhiman Bose
Ashoke Chakrabarty
Desha Kalyan Chowdhury
Kamal Jeet Chugh
Sebastian D'Souza
Pabitra Das
Tapan Das
Saurabh Das
Bikas Das
Rajib De
Noshir Desai
Pranab Dhar
Sunil K. Dutt
Nilayan Dutta
Sanjoy Ganguly
Victor George
Subhendu Ghosh
Alok Bandhu Guha
Fawzan Husain
Rajesh S. Iyer
Jeejo John
Kuriyan Mandumbal Johnson
Aranpakkam M.R. Kannan
Rajan Kapoor
Gautam Kayal
Nafis Khan
Girish Khatri
Achal Kumar
S. Mahinsha
Shyamal Maitra
Ashok Majumder
Sailendra Mal
Varghese Malayil Kuriakose
Sunil Malhotra
Provat Mallick
Aloke Mitra
Suvomoy Mitra
Prashant Kalidas Nakwe
Swapan Nayak
Somnath Pakrashi
Amlan Paliwal
Devadas Pallikunnel Raghavan
Swapan Parekh
Ashoke K. Paul
Mustafa Peediakkal
Kusuma Prabhakar
Shakeel Qureshy
Seshadri Ramanujam
Raghunathan
M.K. Abdul Rahman
Nilanjan Ray
Avijit Roy
Arunangsu Roy Chowdhury
Thannimalayil A. Sabu
Jayanta Saha
Parth Sanyal
Partha Sarathi Sen Gupta
Bejoy Sen Gupta
Ashesh K. Shah
Hemendra A. Shah
Sondeep Shankar
Sanjay Sharma
Jayanta Shaw
Prabhakar Shirodkar
Manikrao Mahadev Shirodkar
Paresh J. Shukla
Ajoy Sil
Devi Prasad Sinha
Rajen M. Thomas
Vinod Virkud

INDONESIA
Harry Aliasgar
Mirza M. Asrian
Barkah
K. Basrie
Beawiharta
Doddy Mandala Gurning
Eddy Hasby
Rio L. Helmi
Kalpana Kartik
Kholid
Kholili
John Latumeten
Pang Hway Sheng
Dedi H. Purwadi
Sandhi Irawan
Sholihuddin
Tarko Sudiarno
Atok Sugiarto
Arief Suhardiman Sutardjo

Toto Sunyoto
Mario Susanto
Paulus Suwito
Sing Hang Tan
S. Tanrawali
Bramantio Tjokro Atmodjo
Tjitra Winarno
Nanung N. Zula

IRAN
Yadollah Abdi Kaloraz
Arash Akhtari Rad
Heidar Amar
Mohammad Reza Arab
Saeed (Sasha) Ashrafi
Ebrahim Bahrami
Taghi Bakhshi Rad
Maryam Bakhsmi
Jamshid Bayrami
Nader Davoodi
Agdar Deldadeh
Javad Erfanian Aalimanesh
Hamid Reza Gilanifar
Aziz Habibirad
Niloofar Haghighat
Hamidreza Hasangholizadeh
Majid Hosseiny Yasagi
Hashem Javadzadeh
Kamran Jebreili
Mohammad Karbalaee-Ahmad
Morteza Kashefi
Masoyd Khameci Poyr
Majid Khamseh Nia
Morteza Lotfy
Manoocher
Behrooz Mehri
Mehdy Monem
Hamid Mozafari
Javad Poursamad
Mahmoud Rafati
Reza
Kavoos Sadeghloo
Mahmoudy Aznaveh Saeed
Mohammad Reza Saffar Zadeh
Madjid Saïdi
Ahmad Salmany
Wahid Salmi
Seifollah Samadian
Jafar Samiei
Farid Sedaghat
Vahe Shahinian
Arash Sharifi
Homeira Soleymani
Ataollah Taher Kenareh
Ali Tamaddon
Nasrin Toraby
Mahdi Yavar Manesh

IRAQ
Nurildin Hussein

IRELAND
Laurence Boland
Colman Doyle
Eric Luke
Dara Mac Dónaill
Adrian Melia
Seamus Murphy
Peter Nash
Jeremy Nicholl
Kyran O'Brien
Bryan O'Brien
Joanne O'Brien
Jim O'Kelly
Joe O'Shaughnessy
Leo Regan
Ray Ryan
Robert Q. Shanley
David Sleator
Mick Slevin
Eamon Ward

ISRAEL
Oren Agmon
Yossi Aloni
Shlomo Arad
Joel Assiag
Daniela Java Balanovsky
Ariel Besor
Yori Costa
Elad Gonen
Hanoch Grizitzky
Emanuel Illan
Ziv Koren
Edi Kosmin
Ragowan Meir
Chen Mika
Ilan Ossendryver
Alon Ron
Jacob Shaltiel
Jonathan Shaul

Nitsan Shorer
David Silverman
Yossi Zeliger

ITALY
Mirko Albini
Marco Albonico
Antonio Amato
Renato Andorno
Fabiano Avancini
Luigi Baldelli
Isabella Balena
Ernesto Bazan
Rino Bianchi
Enrico Bossan
Luca Bracali
Romano Cagoni
Antonio Calanni
Claudio Candito
Alessandro Carpentieri
Ascanio Raffaele Ciriello
Pier Paolo Cito
Francesco Cito
Lucio Cocchia
Claudio Colombo
Marco Costa
Francesco Costanzo
Eugenio Cova
Paolo Dellepiane
Giovanni Diffidenti
Alfonso E. Dossi De Gregoris
Roberto Dotti
Federico Durante
Giuseppe Fassino
Franco Felce
Giuliano Ferrari
Mario Filippo
Fabio Fiorani
Stefano Fiorentini
Giorgia Fiorio
Gianni Fiorito
Enrico Formica
Massimiliano Fornari
Andrea Fuccelli
Giancarlo Fundaro
Angelo Gandolfi
Enrico Genovesi
Piero Giaculli
Gianni Giansanti
Alberto Giuliani
Giuliano Grittini
Guido Harari
Luigi Jorio
Nicola Lamberti
Ciro Lauria
Stefano de Luigi
Valentina Macchi
Francesco Maglione
Alessandro Majoli
Ettore Malanca
Alberto Malucchi
Annunziata Manna
Michele La Manna
Claudio Marcozzi
Enrico Mascheroni
Daniele Mattioli
Ivan Meacci
Giovanni Mereghetti
Dario Mitidieri
Bruno del Monaco
Paolo Monci
Luigi di Nunno
Claudio Olivato
Maurizio Orlanduccio
Carlo Orsi
Agostino Pacciani
Lina Pallotta
Bruno Pantaloni
Eligio Paoni
Maurizio Papucci
Paolo Pellegrin
Daniele Pellegrini
Graziano Perotti
Marco Pesaresi
Fabrizio Pesce
Paolo Petrignani
Giovanni Piesco
Antonio Pisacreta
Adriano Pisoni
G. Angelo Pistoia
Cristina Piza
Franco Pontiggia
Sergio Ramazzotti
Alberto Ramella
Bettina Ravanelli
Susanna Rebuffi
Simeone Ricci
Humberto Ricciardini
Marco Rigamonti
Roberto Rognoni
Andrea de Rose

Andrea Sabbadini
Giovanni Salici
Danilo Schiavella
Massimo Sciacca
Livio Senigalliesi
Fabio Sgroi
Romano Siciliani
Massimo Siragusa
Attilio Solzi
Angelo Turetta
Andrea Vallavanti
Riccardo Venturi
Alessandro Villa
Claudio Vitale
Paolo Volponi
Francesco Zizola
Aldo Zizzo
Vittorio Zunino Celotto

JAMAICA
Junior Dowie
Norman Grindley

JAPAN
Ikurou Aiba
Kazuo Akimoto
Tetsuya Akiyama
Tadahiko Aramoto
Shigetaha Doi
Takao Fujita
Kenichi Funatsu
Satoru Iizuka
Akira Ishihara
Masaki Ito
Takatoshi Kambe
Teruhito Kamiya
Yoshihiro Kano
Kazua Kawabata
Chiaki Kawajiri
Takeshi Kawamoto
Shigeo Kogure
Yukinobu Kurosaka
Shusaku Kurozumi
Hidehiko Matsuda
Toshi Matsumoto
Kimimasa Mayama
Haruki Morishita
Ichiroh Morita
Shinichi Murata
Yutaka Nagakubo
Yoshiaki Nagashima
Takuma Nakamura
Masumi Okamoto
Yoshihiko Okamoto
Kiyohiro Oku
Tatsuya Onishi
Akira Ono
Nobuko Oyabu
Paul Quale
Mitsuru Sakai
Naoki Sakai
Q. Sakamaki
Kazuyoshi Sako
Koji Sasahara
Toshikazu Sato
Yoshihiko Seki
Nobuo Serizawa
Norihiro Shigeta
Ekisei Sonoda
Akira Suwa
Akehi Taemi
Mamoru Takatsu
Akio Tanigawa
Iwasaki Teru
Keigo Tsuruta
Katsuyuki Uchibayashi
Hirohisa Uchida
Masahiro Wada
Kazuhito Yamada
Aiku Yamaguchi
Haruyoshi Yamaguchi
Munesuke Yamamoto
Toru Yamanaka
Mitsu Yasukawa
Koshi Yoshimura

JORDAN
Imad Al-Deen Matahen

KAZAKHSTAN
Farhat Kabdykairov
Uraz Mukhamedzhanov

KENYA
Ivan Kariuki Colbeck
Morris Galavu Masidz
Keyonzo
Sam Ouma

LATVIA
Valdis Brauns

LEBANON
Maroun G. Akiki
Fouad Elkoury
Adour Ourfalian

LIECHTENSTEIN
Eddy Risch

LITHUANIA
Evaldas Butkevicius
Petras Katauskas
Mindaugas Kavaliauskas
Mindaugas Kulbis
Kazimieras Linkevicius
Romualdas Pozerskis
Albertas Svencionis

LUXEMBURG
Claude G. Diderich

MALAYSIA
Jaafar Abdullah
Chong Voon Chung
Chpy Thoong Soon
Goh Seng Chong
Mohamad Ali Ismail
Koh Kok Hwa
Lee Lay Kin
Lim Beng Hui
Lim Chien Ting
Liow Chien Ying
Low Shaw Keat
Lum Woei Hoong
Tajudin Muhd. Yaacob
Ong Choon Min
Sun Swee Meng
Teh Eng Koon
Teh Pek Ling
Yau Choon Hiam

MALTA
Darrin J. Zammit Lupi

MAURITIUS
Sarvottam Rajkoomar

MEXICO
Itzel Aguilera Gonzalez
Carlos Alvarez
Hector Amezcua
Jerónimo Arteaga Silva
Ulises Castellanos Herrera
Fernando Castillo Fuentes
Guillermo Castrejon Martinez
Alejandro Chavez Morales
Isabel Diaz
Sergio Dorantes
Jose Arturo Fuentes Franco
Luis Jorge Gallegos
Arturo Garcia Campos
Hector Hernandez Calderas
Miguel Angel Llamas Parada
Fernando Lopez Romero
Gerardo Magallon Rodríguez
Elsa Medina Castro
Enrique Mejía Hernández
Victor Mendiola Galván
Armando Mendoza Sanchez
Almudena Ortiz
Tomas Ovalle
Marcelo Palacios Rocha
Eugenio Polgovsky Ezcurra
Carlos Puma
Marco Reyes Hernandez
Oscar Salas Gómez
Jorge Suro Cedano
Carlos Taboada Cervantes
Nicolas Triedo
Roberto Velázquez Flores
Jose Villaseca Chavez
Enrique Villaseñor Garcia
Jose Luis Villegas

NETHERLANDS
Peter van Aalst
Jan Banning
Shirley Barenholz
Dennis F. Beek
Frank van den Berg
René van den Berg
Marcel G.J. van den Bergh
Peter Blok
Remco Bohle
Morad Bouchakour
René Bouwman
John Claessens
Peter DeJong
Max Dereta
Roel Dijkstra
Rob Doolaard
Leo Erken

Bram Gebuys
Annie van Gemert
Frits Gerritsen
Ron Gigengack
Aloys Ginjaar
Robert Goddijn
John van Hasselt
T.A.J. Hellegers
Hans Heus
Jan-Willem van den Heuvel
Dick Hogewoning
Sjoerd van der Hucht
Paul Huf
Martijn de Jonge
Geert van Kesteren
Cor de Kock
Frans Marten Lanting
Marinus Laven
Gé Jan van Leeuwen
Serge Ligtenberg
Jaco van Lith
Martien de Man
Michel Mees
Cor Mulder
Benno Neeleman
Lenny Oosterwijk
John Oud
Erik-Jan Ouwerkerk
Diomedes Ramos
Gerhard van Roon
Raymond Rutting
Ewout Staartjes
Koen Suyk
Ruud Taal
Roy Tee
Sander Veeneman
Roel Visser
Henk van Vliet
Klaas-Jan van der Weij
Eddy van Wessel
Emile Wiessner
René de Wit

NEW ZEALAND
Mark Baker
Philippa Blackwood
Wade Goddard
Michael Hall
Arthur Pengelly
Martin de Ruyter
Marion Van Dijk

NIGERIA
Sunday Adedeji
Tunde Akingbade
Ademola Abayomi Akinlabi
Mudashiru Atanda
Adebolu Olandipupo Odunewu
Julius Idowu Ogunleye
Joseph Okwesa
Paul Oloko
Ray Onwuemegbulem
Edoho-Ukwa Bassey Utuk

NORWAY
Marita Aarekol
Oddleiv Apneseth
Lise Aserud
Tore Bergsaker
Roar Christiansen
Harald Henden
Arne Iversen
Erik Wiggo Larsen
Bo Mathisen
Janne Moeller-Hansen
Mimsy Moller
Otto von Münchow
Aleksander Nordahl
Vidar Ruud
Rune Saevig
Helge Skodvin
Finn Eirik Stromberg

PANAMA
Alejandro Mendéz Zambrano

PARAGUAY
Hugo Fernandez

PERU
Martin Bernetti Vera
Jorge Cahuana Romero
Jose Felix Chuquiure Alva
Enrique Cuneo Bermudez
Hector Emanuel
Pedro Jesús Gárdenas Muñoz
Cecilia Herrera
Maria Larrabure Simpson
Fatima Lopez Alva
Hector José Mata Becerra
Maria Ines V. Menacho Ortega

124

Dante Piaggio Díaz
Rolly Alex Reyna Yupanqui
Marcelo Salinas
Walter Donato Silvera Prado
Renzo Uccelli Masías
Maria Consuelo Vargas Daza
Justo Pastor Vargas Sota
Rumi Velaochago Jimenez
Rosa María Villafuerte Salinas

PHILIPPINES
Carlito Arenas
Alex Badayos
Sigfred Balatan
Allan Cuizon
Tonee Despojo
Romeo Gacad
George Gascon
Manuel Goloyugo
Valeriano Tibos Handumon
Andy Hernandez
Victor Kintanar
Francis Malasig
Junjie Mendoza
Ernesto C. Mendoza Jr.
Alfonso Del Mundo
Dennis Sabangan
Nico Sepe
Edwin Tuyay

POLAND
Marcin Balasinowicz
Witold Borkowski
Anna Brzezinska
Arkadiusz Cebula
Antoni Chrzastowski
Stanislav Ciok
Janusz Filipczak
Lukasz Gawronski
Adam Golec
Jerzy Gumowski
Tomasz Gzell
Jacek Janik
Maciej Jawornicki
Piotr Jaxa
Jaroslaw Jurkiewicz
Slawek Kaminski
Krzysztof Karolczyk
Aleksander Keplicz
Jerzy Kleszcz
Rafal Klimkiewicz
Tadeusz Koniarz
Wojtek Korsak
Maciej Kosycarz
Paul Kot
Robert Kowalewski
Hilary Kowalski
Andrzej Kramarz
Witold Krassowski
Przemyslaw Krzakiewicz
Piotr Krzyzanowski
Wojciech Kubik
Robert Kwiatek
Marek Lapis
Karina Lopienska
Gabor Gabriel Lörinczy
Maziej Luczak
Jan Mierzanowski
Krzysztof Miller
Magda Opic
Robert Pawlowski
Marek Piekara
Henryk Pietkiewicz
Miroslaw Prandota
Olgierd M. Rudak
Marcin Rutkiewicz
Maciej Skawinski
Czarek Sokolowski
Maciej Sosnowski
Waldemar Sosnowski
Maciej Stepinski
Piotr Sumara
Maciej Szymczak
Tomasz Tomaszewski
Lukasz Trzcinski
Marek Wachowicz

PORTUGAL
David Aco
Bruno Adelino Ferreira Neves
Luis Pereira Araujo da Rocha
Rita Carmo
Carlos Carvalho
Pedro Catarino
Rui Filipe Costa
Antonio José Cunha
Henrique Delgado
José Manuel Gameiro
Filipe Miguel Guerra
Jose Jorge Guerreiro
Rodriguez Silva

Helena Henriques
Leonardo Oliveira Negrão
Celia Penteado
Cristina Pinto
Joao Miguel Rodrigues
Ulisses Rolim
Paulo Jorge Santos
Jorge Simao
Pedro Sottomayor
João Tuna
João Marques Valentim
Valdemar Verissimo

PUERTO RICO
Heriberto Castro
Ricardo A. Figuerdoa-Rivera
José E. Jiménez-Tirado
Farah M. Rivera
Nydia Mabel Tossas Cordero

QATAR
Salem Al Marri

ROMANIA
Ioan-Matei Agapi
Remus Nicolae Badea
Emil Bánuti
Virginia Boja
Cristian-Partenie Borda
Cosmin Bumbut
Dorian-Manuel Delureanu
Cristian Gatina
Vadim Ghirda
Radu Ghitulescu
Marin Giurgiu
Radu Grindei
Dragos Lumpan
Sorin Mihai Lupsa
Adrian-Constantin Martalogu
Daniel Mihailescu
Florian Munteanu
Teodor Radu Pantea
Iulian Pascaluta
Radu Pop
Tudor Porumb
Aurel Virlan

RUSSIA
Juri V. Abramochkin
George Akhadov
Nickolai Alexandrov
Andrej Arkhipov
Dmitry Azarov
Yuri Balbyshev
Grigory Bedenko
Valeri Blinov
Viacheslav Buharev
Alexander Butkovsky
Leonid Cheljapov
Yrij Chromushin
Valery Degtyarev
Alex M. Degtyaryov
Roman Denisov
Boris Dolmatovsky
Dmitri Donskoy
Alexander A. Drozdov
Vladimir Egorov
Michael Evstafiev
Michael Faizrakhmanov
Vladimir Fedorenko
Igor Gavrilov
Stanislav Gnedin
George Gongolevich
Dmitri Goriatchov
Farit Gubayev
Sergei Halzov
Alexander Karnakov
Yori Kaver
Andrei Kharitonov
Andrei Kholmov
Arkadi Kolybalov
Sergei A. Kompaniychenko
Yevgeni Kondakov
Aleksey W. Kondrashkin
Denis Kozhevnikov
Boris Kremer
Edward Kudryavtsky
Edvard Lapovok
Vladimir Larionov
Oleg Lastochken
Mikhail Logvinov
Alexander V. Lyskin
Sergei Mamontov
Ekaterina Martynova
Vladimir Mashatin
Natalya Medvedyeva
Semyon Meisterman
Andrei Mishenko
Anatoli Morkovkin
Mikhail Moussine
Alexei Myakishev

Sergei Nasonov
Alexander Natruskin
Alexander Nemenov
Yuri Nesterov
Oleg Nikishin
Nikolai Nikitin
Nicolai Nizov
Igor Nosov
Peter Nosov
Vladimir Perventsev
Roman Poderny
Alexander Polyakov
Juri Repich
Vladimir Rodionov
Mikhail Rogozin
Fljera Saifullina
Sergei Samokhin
Alexander Sentsov
Sergei Shakhidjanian
Olga Shalygin
Valeri Shchekoldin
Michail Shilenkov
Roman Shklovsky
Nikolay Sidorov
Oleg Smirnov
Youri Somov
Dmitri Sosulin
Vladimir Syomin
Boris Trepetov
Victor Tshernov
Yuri Tutov
Gennady Usoev
Igor Utkin
Sergei Vasilyev
Vladimir Velengurin
Victor Velikzhanin
Feodor C. Vetrov
Vladimir Vyatkin
Vladimir Yatsina
Juri Zaritovsky
Alexander Zemlianichenko
Anatoly Zernin
Sergei Zhukov
Oleg Zhuravlev
Valeri Zufarov

SAUDI ARABIA
Nabeel Ibrahim Jambi

SINGAPORE
Chang King Boon
Kwok Kwong Jonathan Choo
Choo Chwee Hua
Arthur Lee Chong Hui
Simon Thong

SLOVAKIA
Rastislav Blasko
Jozef Mytny

SLOVENIA
Roman Bezjak
Mirko Kunsic
Tomislav Lombar
Igor Modic
Daniel Novakovic
Andrej Zigon

SOUTH AFRICA
Gary Bernard
Jodi Bieber
Nicolaas de Blois
Cobus Bodenstein
Nicholas Bothma
Colin Davis
Tracey Derrick
Thys Dullaart
Brenton Geach
Anton L. Hammerl
Guy Hobbs
Andrew Ingram
Fanie Jason
Anne Nora Laing
Barry Lamprecht
David Lurie
Herbert Thulani Mabuza
Robert Magwaza
Motlhalefi Mahlabe
Greg Marinovich
Gideon Mendel
Mykel Nicolaou
Obie Oberholzer
Doug Pithey
Etienne Rothbart
David Sandison
Joao Silva
Hannes Thiart
Duif du Toit
Adam Welz
Roy Wigley
Graeme Williams

Debbie Yazbek
Anna Zieminski
Siyabulela Obed Zilwa
Mouton van Zyl

SOUTH KOREA
Ahn
Chang Jong Kim
Choi Kyo-Sung
Kang Duck-Chul
Yong I. Kim
Kim Sunkyu
Sang Youp Lee
Oh Jong Taek
Sung Nam Hun

SPAIN
Tomás Abella Constansó
Diego Alquerache Rodriguez
Jose Luis Alvarez Rubio
Genín Andrada
Francisco Arcenillas Perez
Josá Ballesteros Palencia
Erika Barahona Ede
Juan Carlos Barbera Marco
Alvaro Barrientos Gómez
Eduardo Bayona Estradera
Jordi Bedmar Pascual
Clemente Bernad
Angel Bocalandro Martinez
Paloma Bueno Brinkmann
Benjamin Busto Barrenechea
Alfredo Caliz Bricio
Jose Ignacio Calonge Minguez
Sigefredo Camarero Maria
Fernando Camino Martin
Koro Cantabrana
Julio Carbó Ferrer
David Cardelús Vidal
Alfonso Carreto Ruiz
Jose Carlos Carrión Buchó
Cristobal Castro Veredas
Carma Casulá
Agustín Catalán Martínez
Jose Luis Cuesta Solera
Daniel de Culla
Ricardo Dávila Wood
Josep Esclusa
Majer Etxebeste Belandja
Vicenc Fenollosa Perez
Roberto Fernandez del Castillo
Andres Fernandez Pintos
Javier Fernández-Largo López
Emma Ferrer Torregrosa
Jose Ferro de la Fuente
Enric Folgosa-Marti
David Gala Gallery
Paco Garcia Campos
Francisco González Peréz
Isaac Hernández Herrero
Angel Hernando
Jose Miguel de la Iglesia
Miguel Angel Invarato Inarejos
Julen Alonso Laborde
Jose Latova Fernandez-Luna
Emilio Lavandeira Villar
Clotilde Lechuga
Gorka Lejarcegi Zubizarreta
Jose Ignacio Lobo Altuna
José Angel López Soto
Aimo Lorente
Kim Manresa Mirabet
Irene Marsilla Benlloch
Enric F. Marti
Angel Martinez Colina
Eduardo Martinez Guareno
Cesar Mateu I Beltran
Fernando Moleres Alava
Jose Julian Montes Montero
Sofía Moro Valentín-Gamazo
Isabel Muñoz
José Manuel Navia Martínez
José Miguel Negro Macho
Cristina Nuñez
Francisco Ontañon Nuñez
Quico Ortega Salvador
Pere Pascual Salat
Cipriano Pastrano Delgado
Yolanda Pelaez Fernandez
Avelino Pi
Guillermo Rodriguez Ruiz
Julián Rojas Muñoz
Carlos Rubio Pedraza
Luis Miguel Ruiz Gordon
Pablo San Juan Sáenz
Luis Sanchez Davilla
Diego Sanchez-Crespo
Tino Soriano
Nelson Souto
Patric Tato Wittig
Jorge Torres de Miguel

Pepe Valcarcel Sancho
Jordi Vidal Sabata
Juan Carlos Villagran Teresa
Jaime Villanueva Sánchez
Xulio Villarino Aguiar
Mikel Zabala Markuleta
Miguel Zavala Matteini
Emilio Zazu Imizcoz

SRI LANKA
Idroos Lebbe Shahul Hameed
Sriyantha Walpola

SUDAN
Hassan Hamed Mohamed
Mohamed Nour-El Din Abdalla

SURINAM
Hugo C. Ment

SWEDEN
Martin Adler
Jörgen Ahlström
Torbjörn Andersson
Urban Andersson
Jens Assur
Roland Bengtsson
Stefan Berg
Göran Billcson
Sophie Brandström
Jan Düsing
Ake Ericson
Mikael Forslund
Torbjörn F. Gustafsson
Johnny Gustavsson
Leif Hallberg
Paul Hansen
Bertil Haskel
Tommy Holl
Leif Jacobsson
Thomas Johansson
Peter Kjelleras
Peter Knopp
Björn H. Larsson Ask
Jonas Lemberg
Thore Leykauff
Björn Lindahl
Larseric Lindén
Joachim Lundgren
Tommy Mardell
Jonny Mattsson
Jack Mikrut
Sven Nackstrand
Per Nilsson
Jonas Palm
Michael Persson
Drago Prvulovic
Kai Ewert Rehn
Ulf Ryd
Leif Skoogfors
Göran Stenberg
Per-Olof Stoltz
Ingvar Svensson
Ake Thim
Lars Tunbjörk
Roger A. Turesson
Joachim Wall
Curt Waras
Staffan Widstrand
Jan Wiridén
Karl-Göran Zahedi Fougstedt

SWITZERLAND
Eric Jacques Aldag
Karl E. Ammann
Emanuel Ammon
Manuel Bauer
Marco Beltrametti
Marc Berger
Jürg Bernhardt
Monica Beurer
Robert Bösch
Mathias Braschler
Markus Bühler
Vicente Burgal
Christoph Bürki
Rolf Dürr
Hansjörg Egger
Guido Flueck
Michael von Graffenried
Kurt Grüter
Peter Guggenbühl
Bernhard Haberli-Cuarte
Thomas Hoelblinger
Alan Humerose
Monique Jacot
Hugo Jaeggi
Thomas Kern
LeNeff
Michele Limina
Jürg Messerli

Felix von Muralt
Thomas Muscionico
Massimo Pacciorini-Job
Christian Roth
Didier Ruef
Philip Schedler
Peter Schenk
Hannes Schmid
Roland Schmid
Daniel Schwartz
Ruben Sprich
Michael Stahl
Niklaus Stauss
Toni Thorimbert
Olivier Vogelsang
Roger Wehrli
Thomas Weisskopf
Renato Zambelli
Bruno Penguin Zehnder

SYRIA
Ahmad Fadel Elleh Azzam
Firas El Saleh

TAIWAN
Chien-Chi Chang
Chang Cho Hung
Chen Tsung-Wei
Chung Hung Pan
Dar-Shong Lin
Lake Fong
Lin Daw-Ming
Peng-chieh Huang
Shen Chao-Liang
Sun Sou-jen
Wen-Shing Lin
Wu Gong-Ming
Yang Wen-Chin
Yang Yuan Chih

THAILAND
Jetjaras Na Ranong
Sombat Raksakul
Wuttisarn Sunsarit

TRINIDAD
Darren Bahaw
Sean Drakes
Aldwyn Sin Pang

TUNISIA
Mokhtar Hmima
Saïd Mghirbi

TURKEY
Levent Arslan
Fikret Ay
Celal Demirbilek
Tamasa F. Dural
Riza Ezer
Rusen Güven
Bahri Karatas
Hayrettin Karateke
Süleyman Kayaalp
Sefa Özkaya
Kerem Saltuk
Fatih Fernat Sürmeli
Mürselin Tan
Hatice Tuncer
Cem Turgay
Mehmet Umit Turpcu
Yalçin Çinar

UGANDA
Henry Bongyereirwe

UKRAINE
Vasyl Artyushenko
Vladimir Falin
Vadim Lesnoi
Valery Miloserdov
Valeri Soloviev

UNITED KINGDOM
David Ahmed
John Angerson
Adrian Arbib
Matthew Ashton
Jane Baker
Richard Baker
William Frederick Batchelor
Martin Beddall
Keith Bernstein
Vincent Bevan
Martin Birchall
Ted Blackbrow
Ian Bradshaw
Charles Breton
Zana Briski
Terry J. Bromley
Clive Brunskill

125

Dillon Bryden
Patrick Burrows
Angela Catlin
Orlando Charvetto
Wattie Cheung
Russell Cheyne
Edmund Clark
Steve Connors
Christian D. Cooksey
Paul Cooper
Anthony Cordt
Steve Cox
Tim Cuff
Simon Dack
Haydn Denman
Dawn Derrick
Hamish Devlin
Timothy Dickeson
John Downing
Peter Duncan-Jones
Colin Edwards
Arthur Egerton
Jonathan Elderfield
Steve Etherington
Drew Farrell
John Featherstone
Ian Fieldhouse
Stu Forster
Gordon Fraser
Peter Fryer
Elisabeth Furth
Clynt Garnham
Michael Goldwater
Steven Gordon
David Graves
Glynn Griffiths
Laurence Griffiths
Julia Guest
Andy Hall
Graham Harrison
Joshua Haruni
Andrew James Hendry
Tony Henshaw
Paul Herrmann
James Hill
Jim Hodson
Mike Hollist
Derek Hudson
Simon Hulme
Roger Hutchings
Edward Jones
Jon Jones
Peter Jordan
Suresh Karadia
Elaine Kennedy
Mike King
David Kinsella
Gary Knight
Christine Lalla
Romaine Lancaster
Kalpesh Lathigra
Jon Levy
Nicky Lewin
Barry Lewis
Geraint Lewis
Malcolm Linton
Raymond Little
Paul Lowe
Claire Mackintosh
Alex MacNaughton
Mike Maloney
Richard Martin
Jenny Matthews
Maurice McDonald
Nick McGowan-Lowe
Dod Miller
Sacha William Miller
Allan Milligan
Simon Mizrahi
David Modell
Annabel Moeller
Simon Mooney
Mike Moore
Steve Morgan
Stuart Morris
Steve Morton
Pauline Neild
Simon Norfolk
Jonathan Olley
Dan Oxtoby
Warren Page
Nigel Parry
Robert Perry
Tom Pilston
Martin Pope
Sophie Powell
Mark Power
David Pratt
Steve Pyke
Steve Race
Alan Reevell

Mike Roberts
Stuart Robinson
David Rose
Ian Rutherford
Howard Sayer
Adam Scott
Magda Lucy Segal
Martin D.M. Shields
John Sibley
Neal Simpson
Paul Smith
Richard Smith
Michael Steele
Christopher Steele-Perkins
Graham Stewart
David Stewart-Smith
Tom Stoddart
Christopher Stowers
Paul Duncan Stuart
Justin Sutcliffe
Sean Sutton
Jeremy Sutton-Hibbert
Edmond Terakopian
Andrew Testa
Martin Thomas
Neil Tingle
Robert Todd
John Christopher Tordai
Sion Touhig
Francis Tsang
David Tyrrell
John A. Varley
Howard H. Walker
Darren Walsh
Anton G. Want
Aubrey Washington
Danny Weinstein
David White
Scott Wicking
Geoff Wilkinson
Greg Williams
James Wright
Stewart Writtle
Donovan Wylie
Alex Yeung

URUGUAY
Hugo Daniel Conzie Bermúdez
Gabriel Cusmir Cúneo
Julio Etchart
Antonio Garcia Fernandez
Fernando di Lorenzo Suarez

USA
Jeffrey Aaronson
Curtis Ackerman
David Adame
David J. Ake
Michael Albans
Petrie Alexandra Haxton
William Albert Allard
Alejandro Alvarez
Christopher Anderson
Mary Andrade
Nancy Andrews
J. Scott Applewhite
Jim Argo
Terry Ashe
Jean Louis Atlan
William Auth
Tony Avelar
Ed Bailey
Karen Ballard
William Bangham
Dimitry Baranov
Rebecca Barger
Melanie Eve Barocas
Martha Olivia Barrionuevo
Don Bartletti
Nell Bednarz
Bill Beiknap
Al Bello
Kathryn Bender
Harry Benson
P.F. Bentley
Larry Benvenuti
Alan Berner
Matt Bernhardt
Todd Bigelow
Donna Binder
Molly Bingham
Nancy Elaine Black
Wesley Bocxe
Gary Bodon
Joe Bongi Jr.
Deborah Booker
Lou Bopp
Jean-Marc Bouju
Carl Bower
Torin Boyd
Gary Braasch

Dennis Brack
Heidi Bradner
Alex Brandon
David Brauchli
Milbert Orlando Brown
Brian van der Brug
Roger Bryant
Joe Burbank
Jodi Buren
David Burnett
James Burnett
Barbara Bussell
Alexandra Buxbaum
Renée C. Byer
Zbigniew Bzdak
Roger Camp
William Campbell
Nick Cardillicchio
Joe Cavaretta
Lee Celano
Radhika Chalasani
Lia Chang
Richard A. Chapman
Jennifer Cheek
Philippe Cheng
Laura Chun
André F. Chung
Marshall Clarke
Timothy A. Clary
Bradley E. Clift
Jodi Cobb
Rachel Cobb
Gigi Cohen
Carolyn Cole
John Cole
Jill Connelly
Matthew Craig
Marnie Crawford Samuelson
Douglas E. Curran
Anne Cusack
Meredith Davenport
Robert A. Davis
Michael Delaney
Craig DeMartino
Lou Dematteis
Jasper Dennison
Richard Derk
Victor H. Des Roches
Joseph DeVera
Charles Dharapak
J. Albert Diaz
Anthony V. DiGiannurio
Niccio Dinuzzo
Ellen Domke
David Doubilet
Sean Dougherty
Patrick Downs
Denis Doyle
Paul Drake
Eric Draper
Richard Drew
Robert Durell
Steve Dykes
John Eastcott
Aristide Economopoulos
Claudio Edinger
Ron Edmonds
Davin R.M. Ellicson
Nancy Ellison
Mitch Epstein
Jason Eskenazi
Miguel Luis Fairbanks
Everett W. Faircloth
Richard Falco
Charlene Faris
Patrick Farrell
Gina Ferazzi
José Ismael Fernández Reyes
Karl Merton Ferron
Stephen Ferry
Michael Fiala
John Ficara
Larry Fink
Richard Finke
Cyndi Finkle
Colin H. Finlay
Gail L. Fisher
Christopher Fitzgerald
David Fitzgerald
Mikel Flamm
Bill Foley
Geoff Forester
Greg Foster
Frank Fournier
Charles Fox
Tom Fox
William Frakes
Therese Frare
Leslie Fratkin
Luke Frazza
Ruth Fremson

Gary Friedman
Craig Fujii
Hector Gabino
David Gala
Patricia Gallinek
Sean Gallup
John Gaps III
Alex Garcia
David Garten
Robert Gauthier
Phillip Geller
James Gensheimer
Greg Gibson
Elizabeth Gilbert
Steve Gooch
Jeffry Goulding
Michael Goulding
Monika Graff
Jason Green
Stanley Greene
Patricia Greenhouse
Michael Greenlar
Rene Gregg
Annie Griffiths Belt
Lori Grinker
Norbert von der Groeben
Henry Groskinsky
Stanley Grossfeld
Jack Gruber
Robert Gumpert
Carol Guzy
Dan Habib
Kari René Hall
Maggie Hallahan
Robert Hallinen
Dirck Halstead
Ross Hamilton
Michael J. Hamtil
David Handschult
Thomas Hannan
Charles Harbutt
Brian Harness
Peter Harris
Sheri Harrison
Chick Harrity
David Hartung
Ron Haviv
Dwight Hayes
Kurt Hegre
Darryl L. Heikes
Gregory Heisler
Mark Henle
Gerald Herbert
Ralf-Finn Hestoft
Sandy Hill
Edward J. Hille
Michael Hintlian
Andrew Holbrooke
Jim Hollander
Kevin Horan
David Hornback
Eugene Hoshiko
Rose Howerter
Leo Hsu
Jennifer Hulshizer
Mark Humphrey
Teresa Hurteau
Jared Iwanski
Stephen Jaffe
Rebecca Janes
Kenneth Jarecke
Janet Jarman
Steve Jessmore
Cynthia Johnson
Kim Johnson
Lynn Johnson
Nathan O. Johnson
Tim Johnson
Frank B. Johnston
Lou Jones
Phillip Jones Griffiths
Jayne Kamin-Oncea
Philip Kamrass
Hyungwon Kang
John Kaplan
Catherine Karnow
Katsumi Kasahara
Ed Kashi
Mark Kasner
Marty Katz
Shelly Katz
John Keating
Cliff Keeler
Beth A. Keiser
Caleb Kenna
Charles Kennedy
Lisa R. Kereszi
Lisa Kessler
Robert Glenn Ketchum
Mark Scott Kettenhofen
Robert King

Barbara Kinney
Paul Kitagaki, Jr
Torsten Kjellstrand
Janet Knott
Jim Knowlton
John S. Koch
Michael Kodas
Richard H. Koehler
Rob Kozloff
Anders Krusberg
Karen Kuehn
Amelia Kunhardt
Teru Kuwayama
Kelly LaDuke
Kenneth K. Lam
Kenneth Lambert
André Lambertson
Wendy Lamm
Peter Langone
Kevin Larkin
Rikard Larma
Lester LaRue
Olivier Laude
Jim Lavrakas
Steven Lehman
Mikhail Lemkhin
Paula Lerner
Ron Levy
Andrew Lichtenstein
Ken Light
Steve Liss
John Loengard
David Longstreath
Rick Loomis
Richard Lord
Bill Luster
William Luther
J. Paul MacDonald
Jim MacMillan
H. John Maier, Jr.
Tyler Mallory
Jeffrey Mankie
John M. Mantel
Mary Ellen Mark
Julie Markes
Dan Marschka
Pablo Martínez Monsiváis
Ricardo Mazalan
Craig J. McCormick
Steve McCurry
John McDonnell
Paul McGuirk
David G. McIntyre
Jim McKnight
William Mercer McLeod
Joseph McNally
Wally McNamee
Kent E. Meireis
Michael Melford
Eric Mencher
Peter J. Menzel
Catherine Meredith
Andrea Mihalik
George Miller
Lester J. Millman
Doug Mills
Mark Milstein
Bryan Mitchell
Dr Mark W. Moffett
Genaro Molina
Yva Momatiuk
John Moore
Christopher Morris
Paul Morse
Edward Murray
Lisa Mutz-Nelson
James Nachtwey
Adam Nadel
Jon Naso
Gary Newkirk
Michael K. Nichols
James Nubile
Velina Nurse
Tony O'Brien
Susan Oconnor
Karen Oganov
Metin Oner
Morgan Ong
Edward Opp
Francine E. Orr
Bob Orsillo
José M. Osorio
Kevin Oules
Darcy Padilla
Brian Palmer
Angela Pancrazio
Denis Paquin
Bryan Patrick
Ruben W. Perez
Lucian Perkins
Timothy Pershing

Ed Peters
Brian Peterson
David Peterson
Mark Peterson
Scott Peterson
Mickey Pfleger
Mark D. Phillips
Keri Pickett
Heather Pillar
Javier Augusto Pineda
Joanna B. Pinneo
Richard Pipes
Richard Pohle
Carol Polakoff
Charles Porter, IV
David Portnoy
Louis Psihoyos
Joe Pugliese
Jaydie Putterman
Michael Quan
Alex Quesada
Joseph Raedle
Romy Ragan
Anacleto Rapping
Laura A. Rauch
Anne Raup
David B. Reed
Eli Reed
Robert Reeder
Tom Reese
Lara Jo Regan
Ed Reinke
George A. Reynolds
Eugene Richards
Mark Richards
Paul Richards
L. Jane Ringe
Steve Ringman
Michael Robinson-Chávez
Manuel Rocca
Joseph R. Rodriguez
Paul Rodriguez
Rod Rolle
Matthew Rolston
Ricki Rosen
Frank Ross
Marissa Roth
Jeffrey L. Rotman
Ira Rubin
Lisa Rudy
M.K. Rynne
Robert Sabo
Scott Sady
Paul Sakuma
Carolina Salguero
Richard Sandler
Roger Sandler
Joel Sartore
April Saul
Tony Savino
Stephen Savoia
Reed Saxon
James Io Scalzo
Al Schaben
Eliot Jay Schechter
Stephen Schmitt
James Schnepf
Jake Schoellkopf
Rob Schoenbaum
Andi Faryl Schreiber
David Schreiber
Kathryn Scott
Helayne Seidman
Bob Self
Martin Seppala
Edward Serotta
Dirk Shadd
Daniel Sheehan
Steven Shelton
Shepard Sherbell
Victoria Sheridan
Larry Silver
Ben Simmons
Luis Sinco
Jodie Skillicorn
Lynne Sladky
John Slavin
Lester Sloan
Matt Slothower
Michael Sofronski
Jan Sonnenmair
Pete Souza
Stephen Spinder
Shaun Stanley
John R. Stanmeyer
Steve Starr
Maggie Steber
Holly Stein
George Steinmetz
Gary Stewart
James Stewart

Oleg Stjepanovic
Adam Stoltman
Les Stone
Peter Stone
Scott Strazzante
Richard Steven Street
David Strick
Bruce C. Strong
Anthony Suau
Michael Sutherland
Caroline Suzman
Herb Swanson
Bill Swersey
Thor Swift
John Talbott, Jr.
Susan Tannenbaum
Susan May Tell
Donna Terek
Ted Thai
Shmuel Thaler
Robert P. Thayer
Scott Threlkeld
Michael Tighe
Lonnie Timmons III
Charles Tines
Peter Tobia
William D. Tompkins
Jonathan Torgovnik
Robert Trippett
Linda Troeller
Chip Turner
David C. Turnley
Peter Turnley
Nuri Vallbona
Dyana Van Campen
Franklin Viola
Michael Vitti
Richard Vogel
Thom Vollenweider
William Wade
Tom Wagner
Diana Walker
Richard Walker
William Warren
Jill Waterman
Lannis Waters
Don Watkins
Albert Watson
Susan Watts
Billy Weeks
Steven Weinberg
Spencer Weiner
Adam Weiss
Mac Weist
David H. Wells
Stephanie Welsh
Mary Wentz
John H. White
Steven Wilkes
Kathy Willens
Anne Williams
Clarence Williams III
Mark Wilson
Gordon Wiltsie
Steve Winter
Susan Winters
Michael Wolf
Kat Wolfe
David Wrobel
Norbert Wu
Ron Wurzer
Claire Yaffa
Taro Yamasaki
David Zalaznik
Barry L. Zecher
Sherman Zent
Tim Zielenbach
Fred Zwicky

VENEZUELA
Rodolfo Alejandro Benitez
Enrique Blein Gerstl
Héctor José Castillo Clemente
Alfredo Rafael Cedeno Salazar
Oswer Diaz Mireles
Carlos José Fouguet Girón
Julio Enrique Garcia Diaz
Emilio R. Guzmán Hernández
Freddy A. Henriquez Salcedo
Ifronny del Valle Hernandez
Alexis Perez-Luna
Angel W. Rizo Arenas
Vladimir Sersa Zvab
Luis Vallenilla Garcia
Alejandro Van Schermbeek

VIETNAM
Bon Ho Xuan
Bui Xuan Long
Buu Van Le
Chau Duong Van

Dan Doan
Dang Anh Duy
Dang Ngoc Thai
Dang Quang
Dang Viet Hung
Dao Nam Trung
Dinh Van Son
Dinh Xuan Dung
Do Anh Tuan
Do Dien Khanh
Dong Le Danh
Ha Tuong
Ho Ngoc Son
Ho Thanh Thoan
Hung Mai Thiet
Huynh Nam
Khanh Lai
Kien Vo Trung
Lam Bang
Lam Hong Long
Le Dinh Song
Le Hong Linh
Le Huu
Le My Phuong
Le Ngoc Tuan
Le Nguyen
Le Quang Hoang
Le Quang Trung
Le Vi
Lien Trinh Ngan
Long Bui
Long Thanh
Luong Chinh Huu
Ly Hoang Long
Mai Xuan Linh
Minh Quang Dao
Minh Quang Ngoc
Ngoc Quang
Nguyen Dac Ngoc
Nguyen Dan
Hanh Nguyen Dang
Nguyen Dinh Lac
Nguyen Duc Chinh
Nguyen Hoang Minh
Nguyen Hona Nga
Nguyen Hung
Nguyen Huu Thanh
Nguyen Ngoc Lan
Nguyen Nhung
Nguyen Phuoc Loc
Nguyen Quoc Thinh
Nguyen Quoc Tuan
Nguyen Tan
Nguyen Tan Diep
Nguyen Tat Binh
Nguyen Thao
Nguyen The Ky
Nguyen Tho
Nguyen Tien Phuc
Nguyen Trung
Nguyen Trung Bo
Nguyen Trung Thuc
Nguyen Tuan Nua
Nguyen Tuyet Minh
Nguyen Van Ngoc
Nguyen Vietthao
Nhut Huynh Minh
Nong Tu Tuong
Nu Dao Hoa
Pham Anh Tuan
Pham Ba Thinh
Pham Dinh Quyen
Pham Duc Thang
Pham Huu Tuy
Pham Kim
Pham Tue
Pham Van Ty
Pham Vudung
Phan Loi
Pho Van Hoi
Phu Hung
Quang Hanh
Quang Nguyen
Quang Trong
Que Nguyen Van
Quy Tran
Si So Ho
Ta Hoang Nguyen
Thang Duong Quang
Thang Le Xuan
The Dinh Nguyen
The Phan
Thi Tho Doan
To Giang Ngo Minh Luan
Ton That Duyet
Tran Anh Khoa
Tran Cu
Tran Dan Que
Tran Duc Suu
Tran Duc Tai
Tran Huong

Tran Huu Cuu
Tran Huu Von
Tran Minh Cuong
Tran Quang Tuan
Tran Quoc Tuan
Tran San
Tran Son
Tran The Long
Trieu Phung
Trongh Dung Hoang
Truong Hoang Them
Truong Trong Hieu
Tu Thanh
Tu Tien
Vo Thanh Tung
Ung Quoc Binh
Van Bao
Van Xuan Nguyen
Vinh Quang Tran
Vo Van Thanh
Vu Anh Tuan
Vu Kim
Vu Quang Huy
Xuan Mai

YUGOSLAVIA
Zoran Anastasijevic
Darko Cirkov
Milos Cvetkovic
Danijel Grujic
Zoran Jovanovic
Aleksandar Kelic
Sasa Maksimovic
Dragan Milovanovic
Zoran Milovanovic
Mihály Moldvay
Djordje Popovic
Mico Smiljahic
Goran Tomasevic

ZAMBIA
Webson Chanda Mumba
Asiah Nebart Mwanza
Chatowa Ngambi
Patrick Ngoma
Timothy Nyirenda

ZIMBABWE
Onward Charakupa
Major Gurupira
Costa Manzini
Gibson Mapokotera
George Muzimba
Regis Nyandima
July Shamu
Fidelis Zvomuya

Hurdler © Bill Frakes, 1996.

KODAK. TAKE PICTURES. FURTHER.

Of all the world-class venues at the 1996 Summer Olympic Games in Atlanta, one will get more media attention than any other. It's the Kodak Imaging Center. The largest commercial imaging center the world has ever seen. From film to digital capture, processing to scanning, printing to digital transmission, it will offer the best photojournalists in the world everything they need to capture, process, scan, and transmit their images. Helping them overcome hurdles. So they can concentrate on getting the big picture.

Kodak
Official
Sponsor
of the
1996
Olympic
Games

Atlanta 1996

The Canon EOS 50E. A stroke of true genius.

For The Enlightened.

The human eye - subject of fascination for centuries and the inspiration behind the basic principles of photography.

Now Canon has moved forward again with the development of EOS 50E. Eye-control focus brings you intelligent optical technology that follows the natural movement of the eye, constantly readjusting to make your subject sharper, clearer.

Which, in turn, gives you more freedom to concentrate on composition - making the final results more immediate, more professional.

But in the application of science we haven't forgotten aesthetics. The EOS 50E's tough yet lightweight body, designed with modern ergonomics for comfort and ease of use, also reflects the qualities and attention to detail which give it the look and feel of a classic camera.

Canon EOS 50E

Canon Europa N.V., P.O. Box 2262, 1180 EG Amstelveen, the Netherlands

*A Dramatic History of
Postwar Photo-Reportage from
Thames and Hudson*

THIS CRITICAL MIRROR

Photojournalism since the 1950s

EDITED BY STEPHEN MAYES
FOREWORD BY SEBASTIÃO SALGADO

From the Archives of the World Press Photo Foundation –
200 Powerful Images by International Photographers

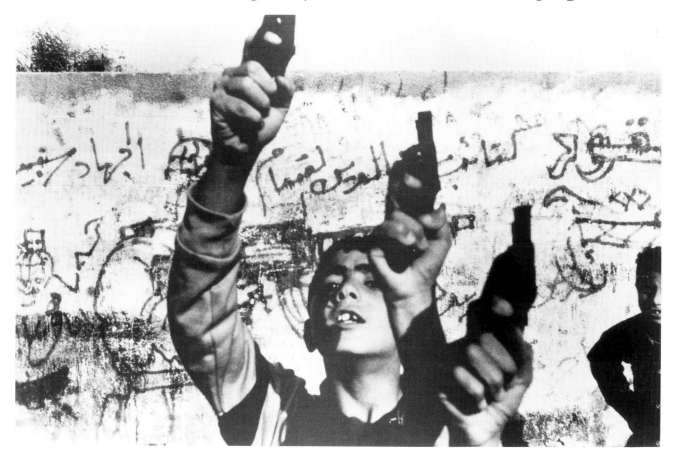

With 234 photographs, 54 in colour 225 pages Paperback 32 x 24cm £19.95/$29.95

For details of our new and forthcoming publications, please write to:
(UK) Thames and Hudson Ltd. 30 Bloomsbury Street, London WC1B 3QP
(USA) Thames and Hudson Inc. 500 Fifth Avenue, New York, New York 10110

Copyright © 1996
Stichting World Press Photo Holland,
Amsterdam
Sdu Publishers/Koninginnegracht,
The Hague
Photography Copyright
© by the photographers

First published in Great Britain in
1996 by Thames and Hudson Ltd.,
London

First published in the United States
of America
in 1996 by Thames and Hudson Inc,
500 Fifth Avenue,
New York, New York 10110

Art director
Hans van Blommestein
Designer
Louis Voogt
Picture coordinators
Marije Oosterhek
Linda Steuernagel
Interview & captions
Terri James-Kester
Editor
Kari Lundelin

Lithography
Nefli, Haarlem
Paper
Royal Impression satin 135 g
Cover Royal Impression satin 300 g
KNP Leykam, Maastricht
Proost en Brandt, Diemen
Printing
Sdu Grafisch Bedrijf, The Hague
Binding
Hexspoor, Boxtel
Production supervisor
Rob van Zweden,
Sdu Publishers, Koninginnegracht,
The Hague

**British Library Cataloguing-in-
Publication Data**
A catalogue-record for this book is
available from the British Library.

ISBN 0-500-974365

Printed in the Netherlands

World Press Photo
Jacob Obrechtstraat 26
1071 KM Amsterdam
The Netherlands
Telephone +31 (20) 6766 096
Fax +31 (20) 6764 471
e-mail: office@worldpressphoto.nl
Managing director: Marloes Krijnen

Front cover
Luc Delahaye,
France, Magnum Photos for
Newsweek Magazine, USA
'UN Soldiers and Refugees, Tuzla,
July 1995'

Title page
Stephan Savoia,
Associated Press, USA
'Clinton and Yeltsin Press
Conference, New York,
23 October 1995'

Back cover
Eric Bouvet,
Le Figaro Magazine, France
'Russian Special Forces, Chechnya'